HOW TO WRAP FIVE EGGS

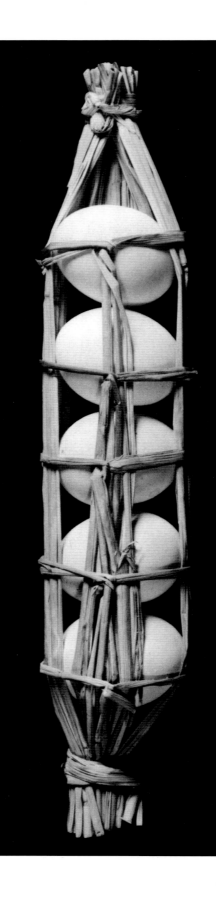

HOW TO WRAP FIVE EGGS

Traditional Japanese Packaging

Hideyuki Oka
With photographs by Michikazu Sakai

Weatherhill | Boston & London | 2008

CONTENTS

Introduction 7

Photographs 13

Commentaries on the Photographs 191

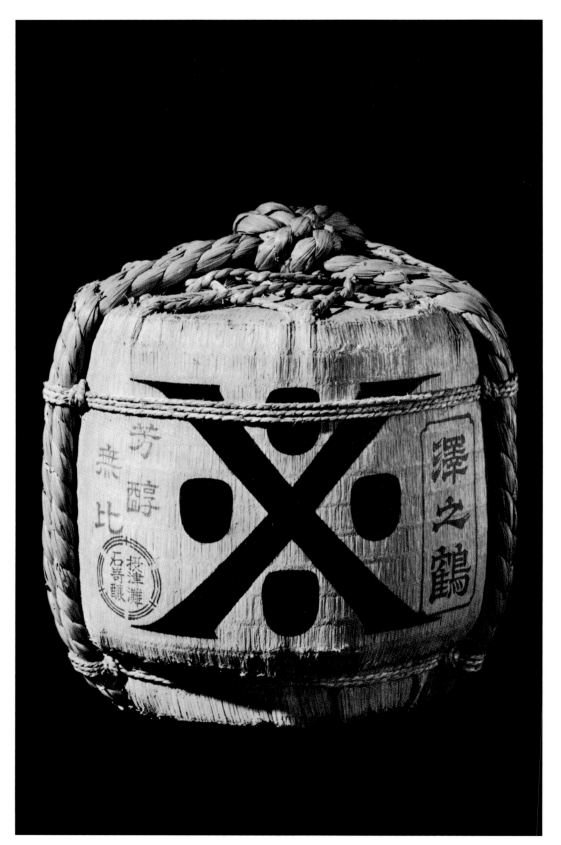

INTRODUCTION

THIS IS MY THIRD BOOK on traditional Japanese packaging. By calling it
How to Wrap Five More Eggs * I have wanted to acknowledge that it is
based upon and retains many of the favorite photographs from my first
book, *How to Wrap Five Eggs,* which is now out of print. Also, the "more"
in the title is a token of the fact that the book contains many more, and
many new photographs.

That first book was published in Japanese in 1965, with an English
version two years later. But it was many, many, many years earlier that I
first fell under the spell of Japanese packaging. And it was in about 1959,
when I was asked to send Japanese contributions to an international
packaging exhibit at the Museum of Modern Art in New York, that I be-
gan seriously collecting and doing research. Now it is almost 1975, and I
find myself still collecting and researching, again for an exhibit in America.
This new exhibit is to consist entirely of Japanese packaging and is to tour
the United States for two years. Thus has it come about that the later
years of my life have been largely devoted to what started out to be only
a leisure-time hobby.

During these years of close involvement—almost two decades, even
at a conservative reckoning—the art of Japanese packaging has been
disappearing almost as fast as my interest in it has increased. Even in the
past ten years it has become impossible to find a number of the examples
and techniques that were shown in my first book.

Japan today is a far cry from the world symbolized by its traditional
packages. That world simply no longer exists except perhaps in a few
inaccessible and forgotten spots. Even to us Japanese it is a world that is
beginning to be remembered only as a vestige of the past or, in the case of
younger Japanese, one that has become only a myth. I have felt it my duty
to save whatever I can of this transient, vanishing art. Once every aspect of
Japanese life was imbued with the spirit that produced this art. Can we now
condemn it to oblivion without even so much as a funeral hymn? Can we
let it go forever, not even asking ourselves: "If the craftsmen and 'designers'

· · · · ·

* This work was originally published under the title *How to Wrap Five More Eggs.* This reissue is
 titled after the author's first book, which contained much of the same content. See p. 274 for
 further information on the publishing history. —Editors

of old Japan could create beauty with their materials, are we today to accept defeat when faced with our new materials and new way of life?"

Just what are these packages whose passing we lament? They are difficult to define in words. Actually, the best way to understand them is to see and experience them. Such packages were not products of contemplation, nor yet of theory. They assumed their shapes over the years and years of unself-conscious use and experimentation, which is to say that this packaging is one form of Japan's cultural heritage. It was not perfected overnight: behind each of these humble packages lie generations of art and craft.

Traditional packaging constitutes a world in itself, made up of a complex network of many distinct sources, sources that in themselves are far from simple. Let us look at two of the principle sources or lineages.

First and foremost is that source that might be called the utilitarian lineage, a kind of crystallization of the wisdom that comes from everyday life. Doubtless the earliest packaging was accomplished by wrapping a given object in whatever material lay at hand. The outcome was often not only adequate for storing and transporting the object but might well have been a simple, beautiful shape free of all excess and extravagance. One example would be the straw holders for eggs (p. 26). This shows once again that necessity is the mother of invention. Eggs are fragile and need protection. With rice as his principal crop, how easy and natural it was for a farmer to wrap his eggs in a few wisps of rice straw, a material whose strength and flexibility made it ideal for this purpose! The resulting "package" was remarkably ingenious. Not only did it afford great protection to its fragile contents, but, even though entirely unconsciously, it also enhanced the feeling of the freshness and warmth of newly laid eggs.

Another example of utilitarian packaging is the rope wrapping for dried fish (p. 134, left). This permits just the right amount of ventilation, thus preserving the fish for more than six months, and the package can also be unwrapped just a bit at a time as needed. This is what I mean by "wisdom that comes from everyday life." The same sort of wisdom is seen in the rope wrapping used for dried persimmons (p. 139, right) and other foods, a technique still to be found in many different parts of rural Japan. Another food wrapping that occurs in many different places is that of bamboo leaves around rice dumplings (p. 33). Other similar wrapping materials that were formerly widely used were oak leaves (for wrapping rice cakes), the edible leaves of the beefsteak plant (for pickled plums), and magnolia leaves (for rice balls or bean curd).

Who could find anything to criticize about these utilitarian wrappings,

these crystallizations of everyday wisdom? In no way self-conscious or assertive, these wrappings have an artless and obedient air that greatly moves the modern viewer. They are whispered evidence of the Japanese ability to create beauty from the simplest products of nature. They also teach us that wisdom and feeling are especially important in packaging because these qualities, or the lack of them, are almost immediately apparent. What is the use of a package if it shows no feeling?

The second clearly recognizable lineage is what we may call handicraft. This involves more highly developed techniques and more refined aesthetic sensibilities. Departing from considerations of sheer utilitarianism, the packagers of this lineage were self-conscious craftsmen who endeavored to refine their methods and did so in a spirit of artistry. For them the act of packaging came to have important meaning in itself quite apart from the importance of the contents of the package. The package came to have a symbolic value quite distinct from its practical function. As techniques became more and more sophisticated, the art of packaging became professionalized. It was a profession followed by artisans working in old, long-established shops. These were dedicated people who took pride in developing the techniques, in making more and more beautiful packages, until at last they achieved a level of competence so high as to constitute a unique peak in the history of packaging.

This was the beginning of packages as works of art, as products that often had more charm and more value than the actual contents of the packages. Packaging had become an end in itself. The motivation of these artisans was entirely personal. They could not resist the desire to perfect their art. They were driven by two considerations: an aesthetic philosophy that said everything could and should be made beautiful and a value system in which all objects, large or small, expensive or cheap, were of real value. Today our sense of values is quite different, and we often wonder why those long-ago artisans took so much trouble, spending so much time and energy in wrapping unimportant, humble objects. The answer lies in the traditional Japanese sense of values.

It is particularly in the old shops that still survive in and around Kyoto that we find most of the fine examples of this type of packaging. This is because Kyoto was both the political and cultural center of the nation for almost a thousand years. Hence the elegance and refinement that characterize this lineage of packaging have come to be known as *kyofu,* or "Kyoto style." For representative examples of this lineage see Kyoto's

many confectionary packages (e.g., p. 63) and the bucket for river trout (p. 23) from the still older capital of Nara.

Today we often seem to think that consumption, not conservation, is the aim of life. Fortunately, vestiges from a wiser past keep recalling us to our senses. The handicraft art of packaging, for one, suggests again and again that maybe everything is not meant to be thrown away. May it not well be that we have finally reached the point where we must reexamine the bases of our modern value system?

Besides these two lineages there are also three characteristics of traditional Japanese packaging that are worthy of note. First there is the natural quality of most packages. The most frequent materials are wood, bamboo, straw, and clay, or derivatives of these materials such as paper, cloth, and ceramics. These are all familiar materials that abound in our natural surroundings and have been used in unspoiled ways since ancient times. The important point is that these natural materials are used in such a way as to show their freshness and their nature textures.

The conflict between man and nature seems to have been one of the bases of Western civilization. In Japan, on the other hand, man has usually lived as part of nature, being embraced by it and commingling with it. This doubtless explains why the most distinguishing characteristic of traditional packaging is the natural element. The Japanese view of nature as being a friend rather than an opponent suggests that today Japan should be in the vanguard of the movement to protect mankind's natural environment.

But to return to packaging, the beauty we find in its materials is largely the beauty of nature; witness the fresh green bamboo leaf, the soft gleam of the bamboo stem, the dignity of cryptomeria bark, the charming pattern of grain in paper-thin shavings of wood. But note that in each case the natural beauty is not used exactly as it originally existed but is recreated in some form or other by the hand of man. Thus natural elements are manipulated in such a way as to become symbols of nature in our daily lives. This is the Japanese way of communion between man and nature: the two are deeply and permanently associated by mutual affection.

Another characteristic common to many forms of traditional Japanese packaging is the aesthetic consciousness of propriety. This is a result of considering wrapping and packaging as a sort of sacred ritual. I have already observed that since ancient times the Japanese have regarded all things as being of value. Another ancient concept that still remains in our

cultural memory is that of cleanliness and uncleanliness. The act of packaging an object becomes, then, a ritual of purification, of distinguishing the contents of the package from all similar objects that have not been purified. Traditional packaging is thus a reflection of Japanese psychology, which doubtless accounts for much of its orderliness and tidiness.

A third characteristic of our packaging is that of handwork. Such packaging would be impossible without the touch of the human hand. Take any traditional wrapping or packaging and you are sure to find a subtlety of handwork that is uniquely Japanese. Note with what patience and skill a Japanese will wrap something in such a trivial object as a *furoshiki,* which is nothing more than a simple square of cloth when unfolded. But the point I would like to make here is not the manual dexterity of the Japanese; it is rather the feeling of love and consideration for others that motivates them to do this handwork. Even in the case of a small cake, say, whether you are giving it as a gift or selling it to a customer, you take the trouble to wrap or package it prettily, no matter how troublesome or inefficient the act may be, simply because you hope that whoever receives it will enjoy opening the package and eating the cake. This is what I mean by love and consideration. One of the reasons why traditional packaging has been disappearing so rapidly in our modern society is that it is so inefficient as to make mass production impossible. And may this not also indicate that we are rapidly losing our human capacity for love and consideration?

No one can deny that the modern system of mass production, whereby a large number of commodities of uniform shapes and qualities are produced by use of the most advanced techniques, has made our daily life comfortable and easy. But should we not pause to reflect and ask ourselves whether we have not suffered a huge and irrevocable loss in exchange for so much convenience and so much emphasis upon material values? This, I think, is one of the lessons to be learned from our traditional packaging—that our inner, spiritual satisfaction cannot be found merely in material abundance. In this sense traditional Japanese packaging is nothing less than a manifestation of the Japanese love of spiritual things, a love that we, and people everywhere in this modern world, must make haste to reclaim unless it is to vanish forever.

Hideyuki Oka
freely translated from the Japanese by A.M. and M.W.

PHOTOGRAPHS

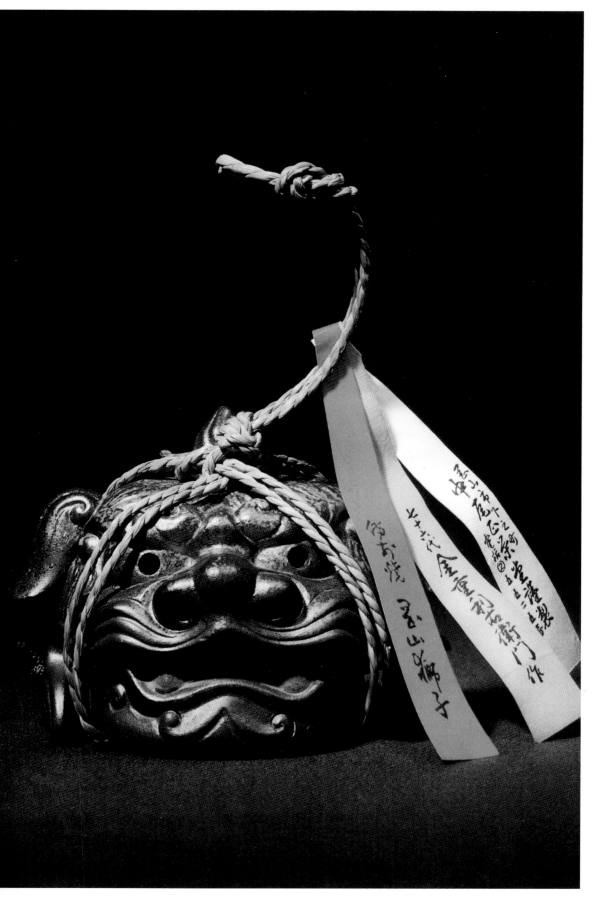

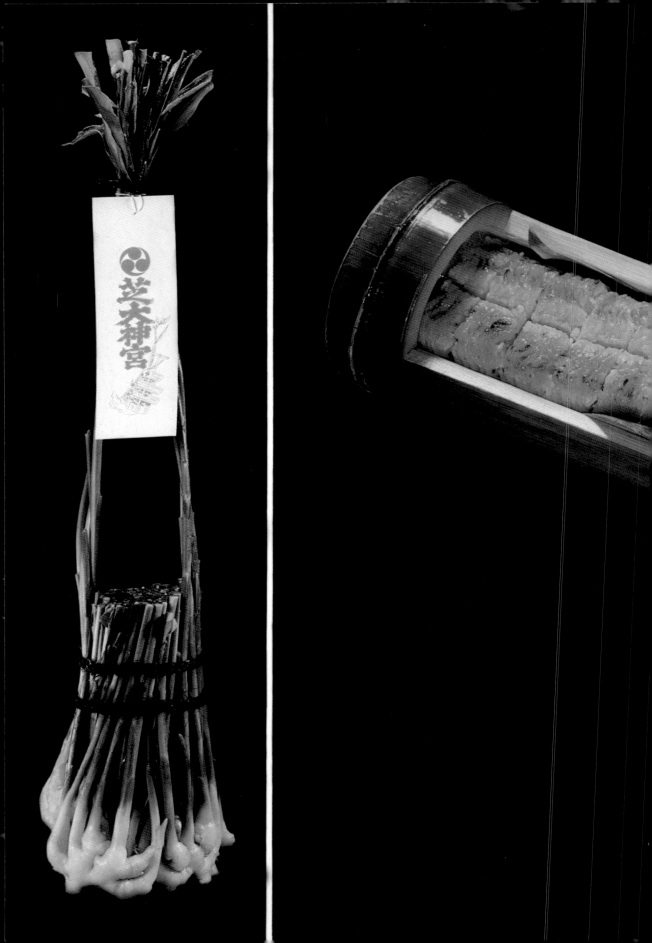

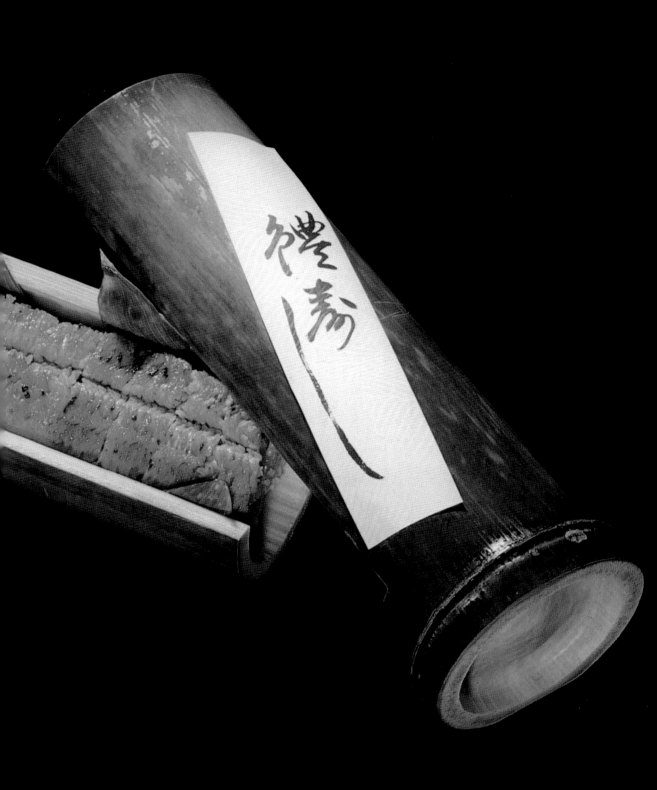

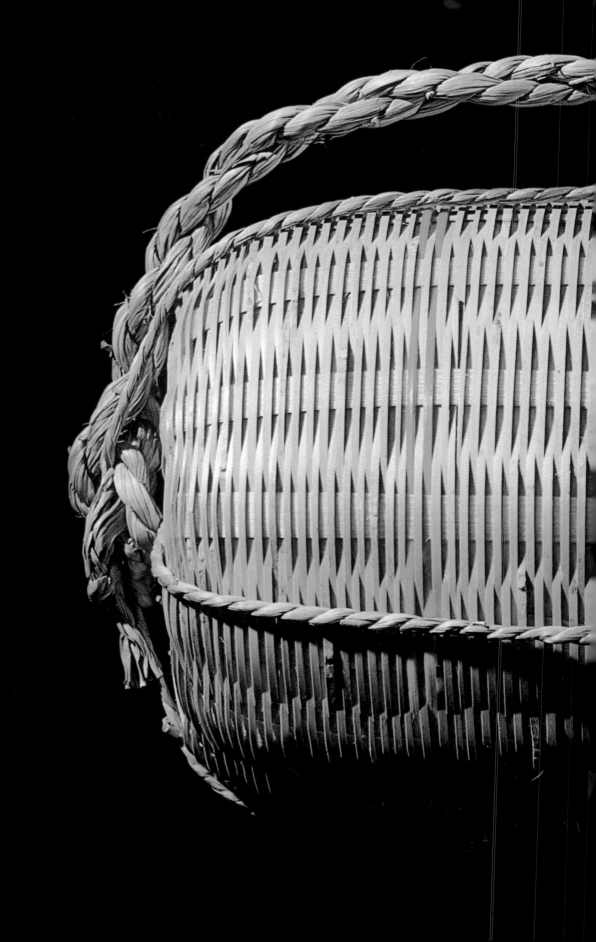

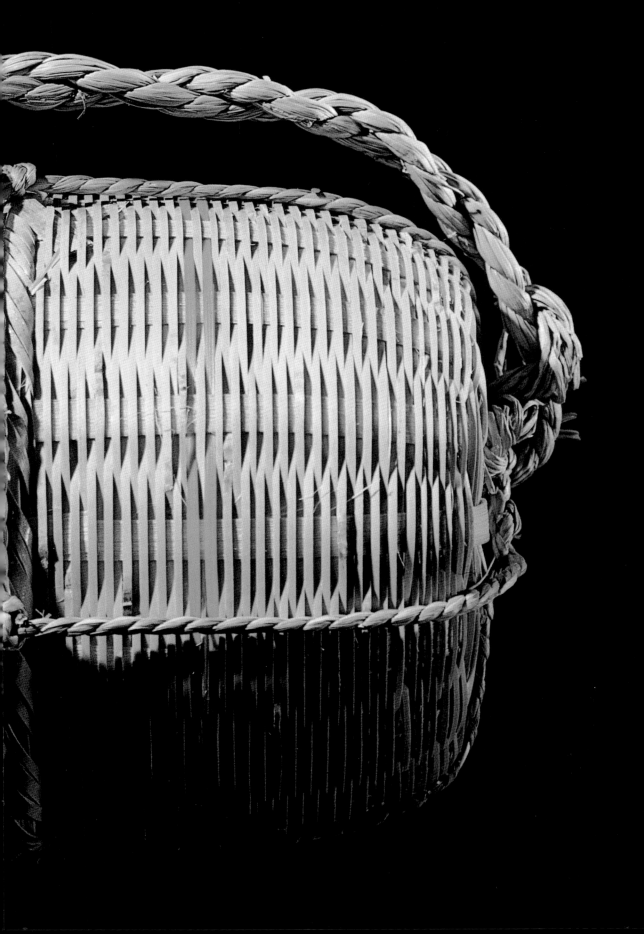

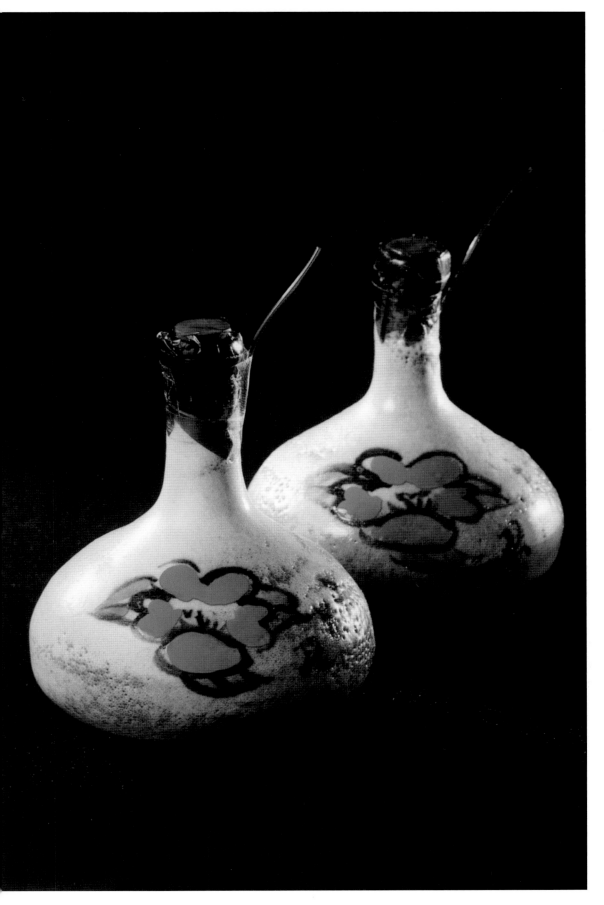

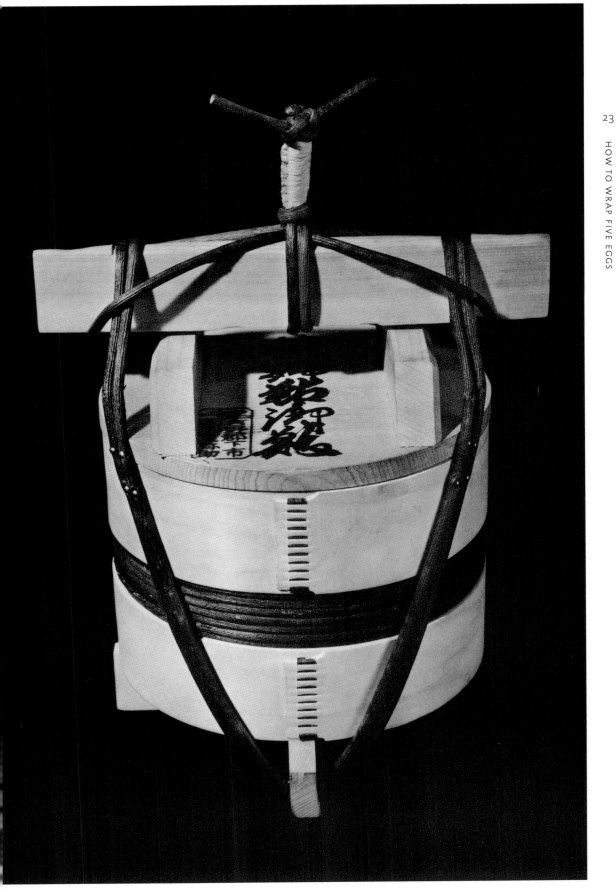

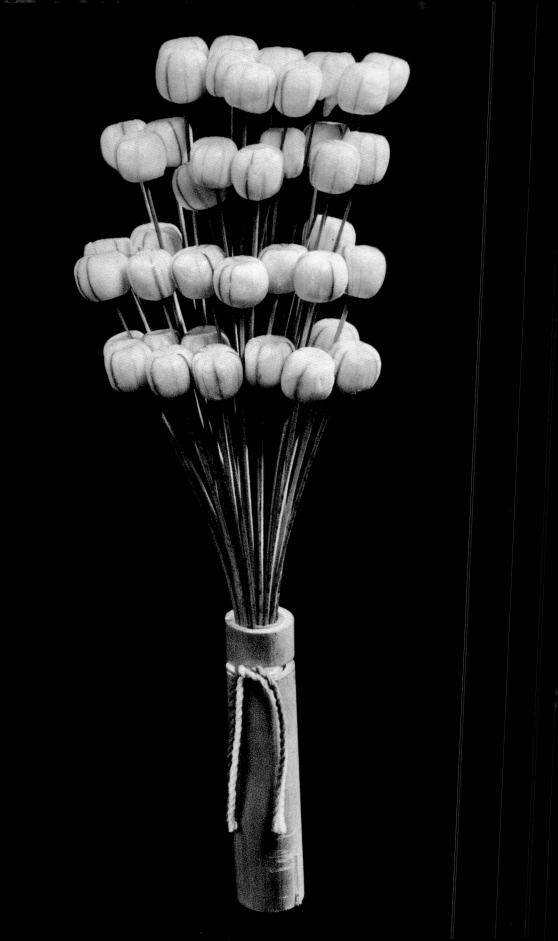

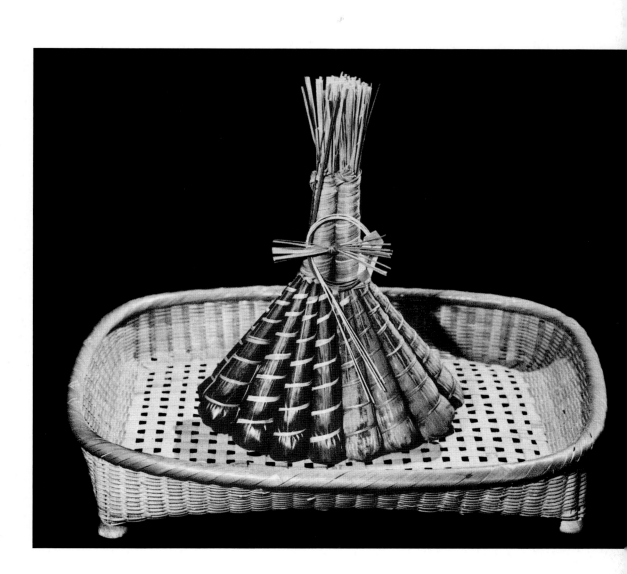

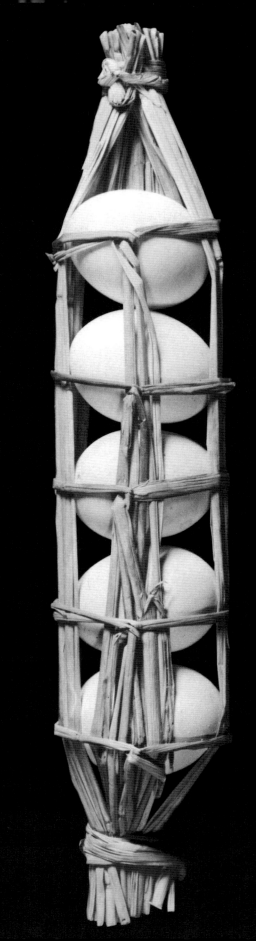

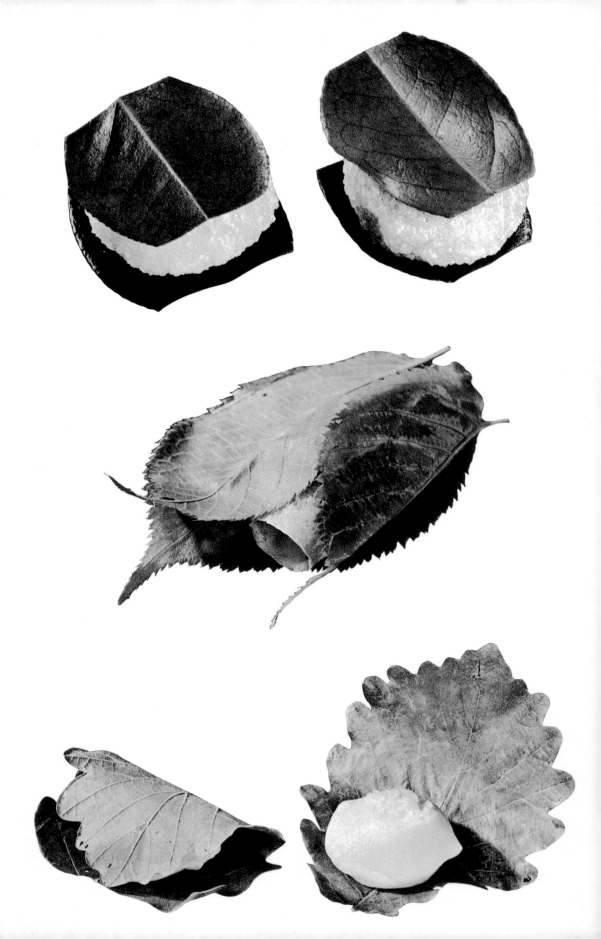

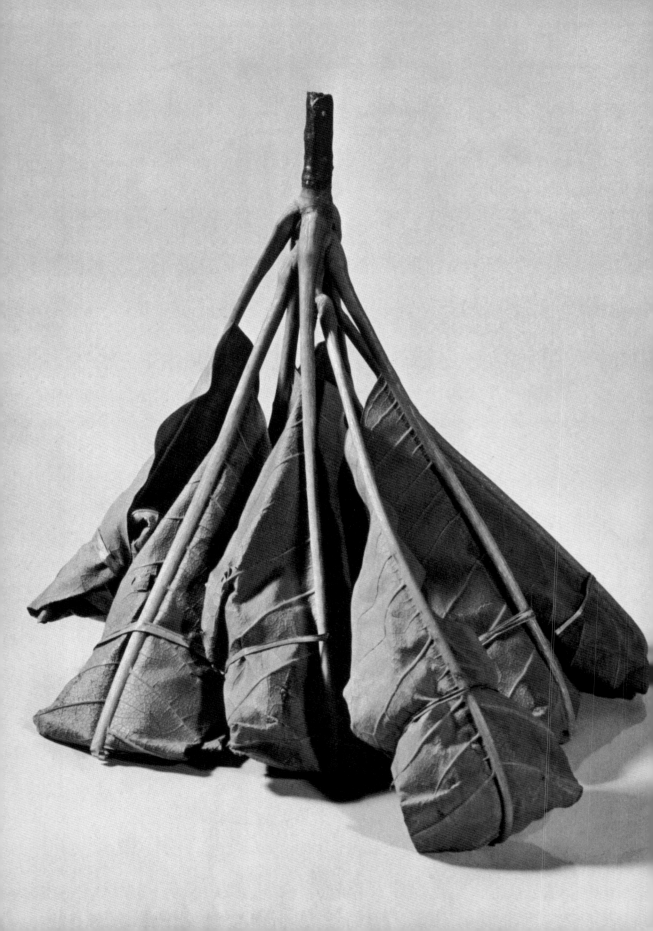

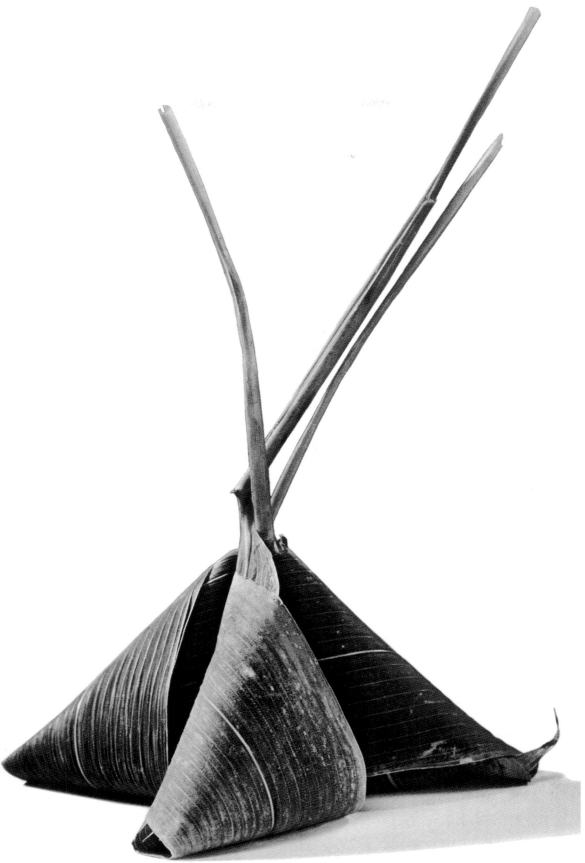

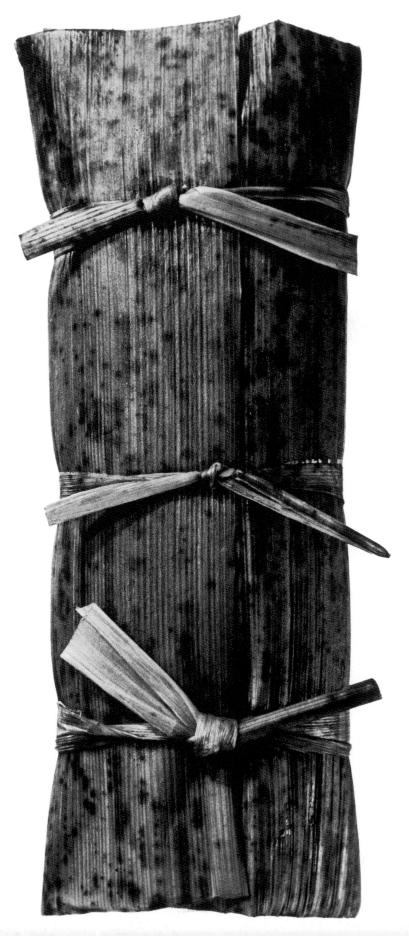

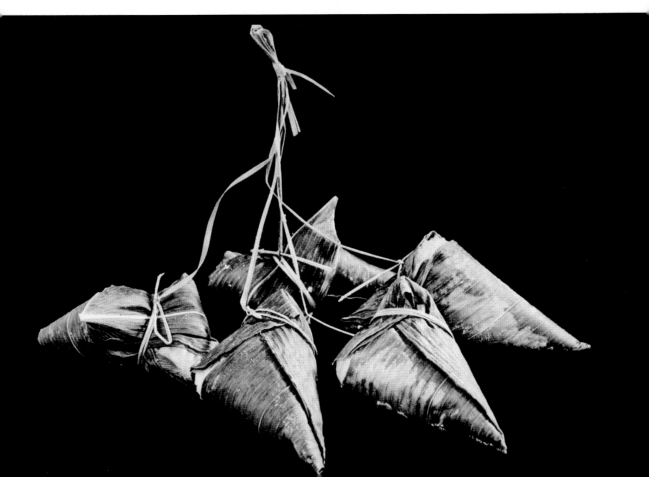

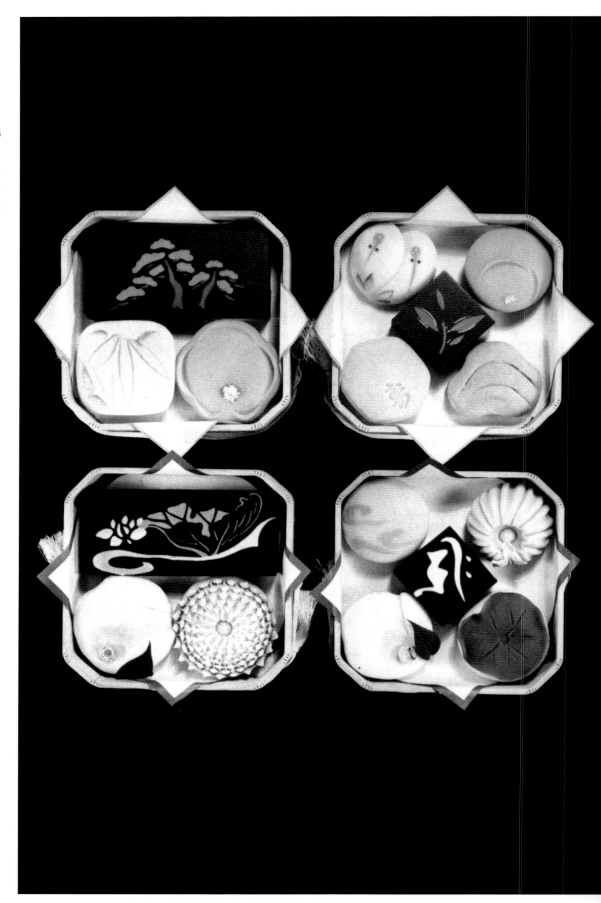

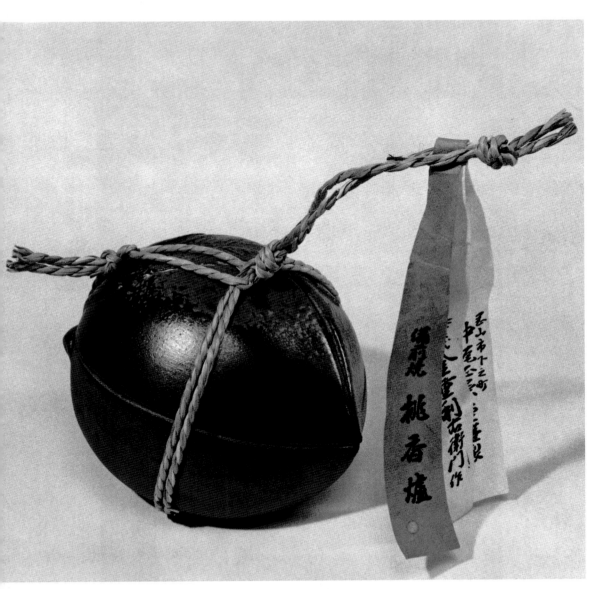

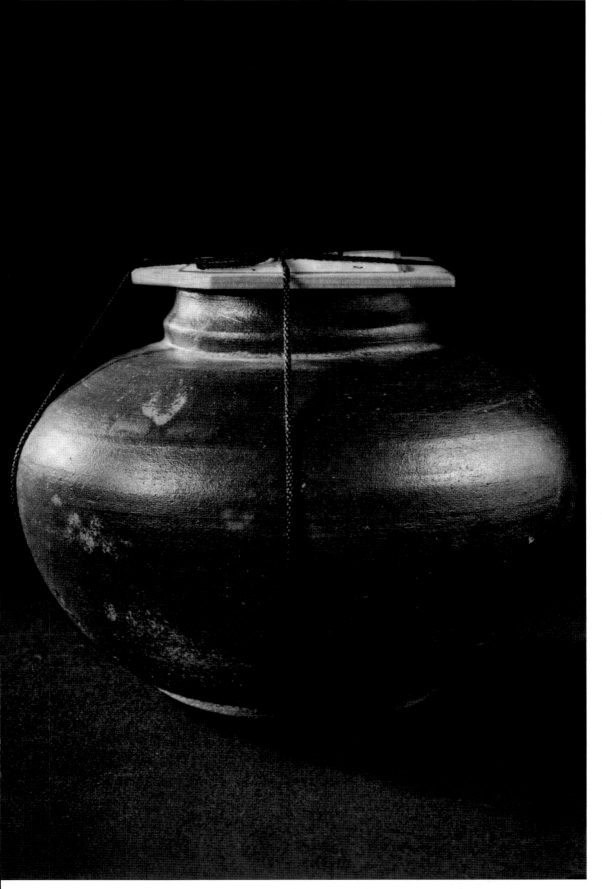

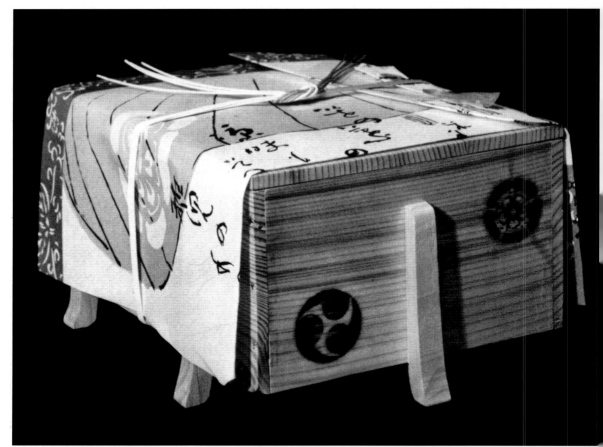

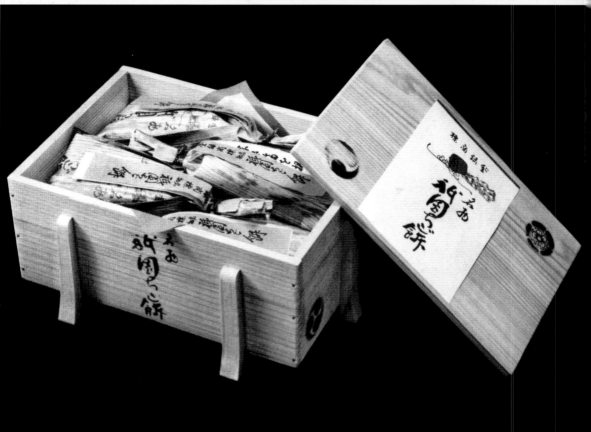

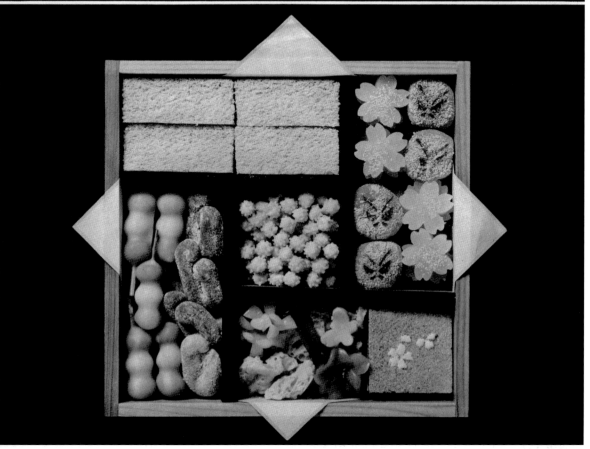

白以良

白以良

白以良

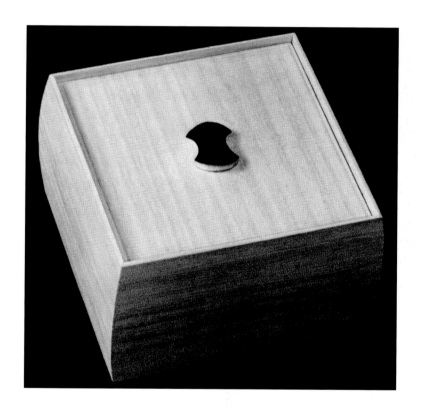

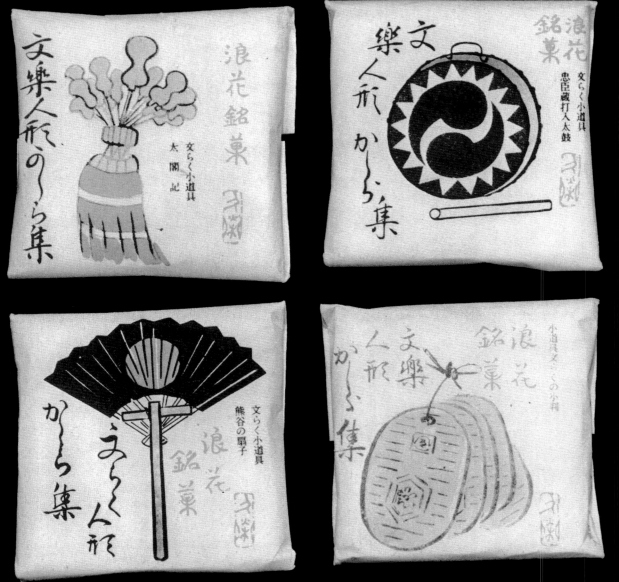

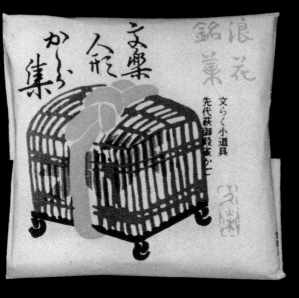
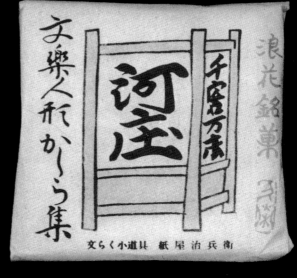
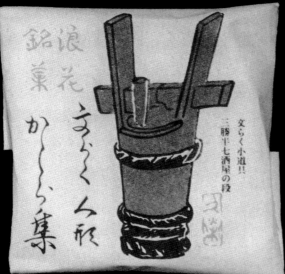
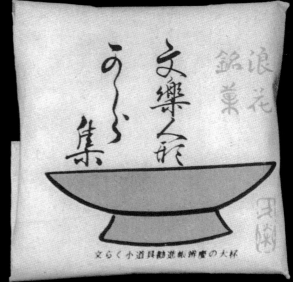

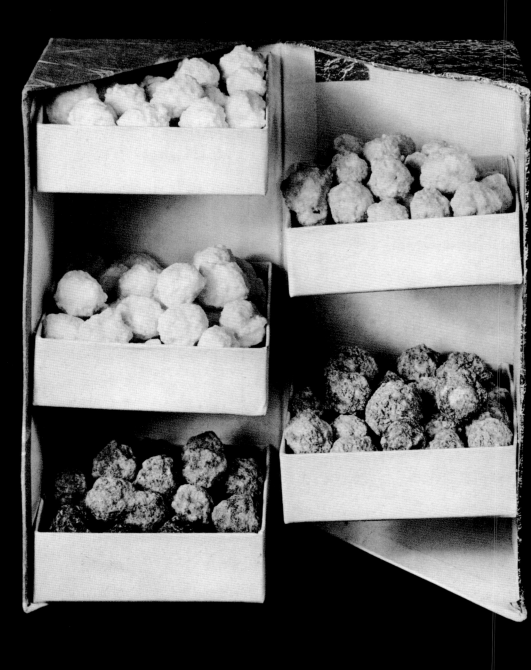

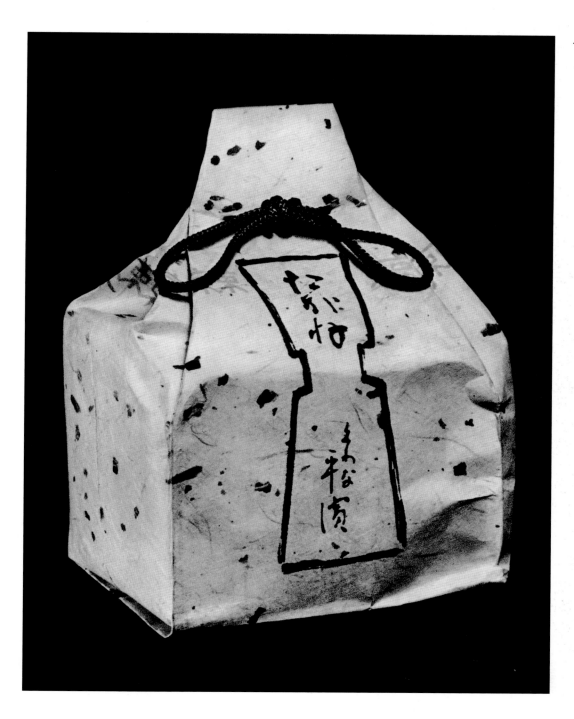

「猿飛羊かん」に寄せて

戦国の昔、大いに活躍した真田十勇士の中に、神出鬼没の忍者猿飛佐助がある。

愛蔵万点、軽妙洒脱、しかも誠忠無比。今もなお万人に愛されている。

真田の居城、信州上田は、彼が生れ、育ち、修練したゆかりの地。

上田城趾の古松、古井戸、古石垣には彼の足あとが残っている。

上田の老舗昌平堂が、今度創案した猿飛羊かんは、忍者の

お召上りの節は糸を静かに下の方へお引き下さい。

栂を開いても入用の分だけお切りになり元通り上栂にお入れになりますと御保存にご便利でございます

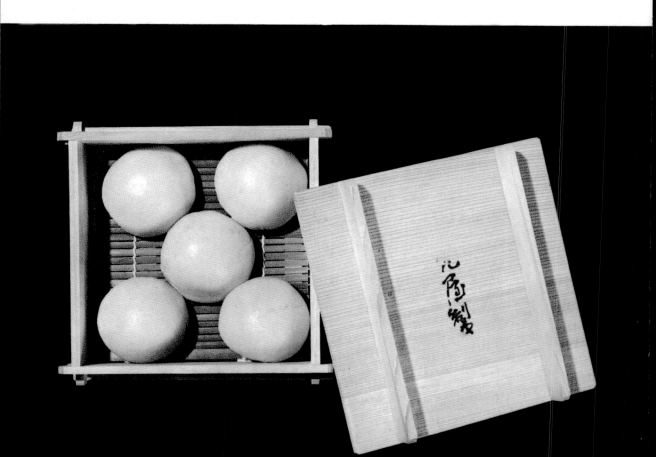

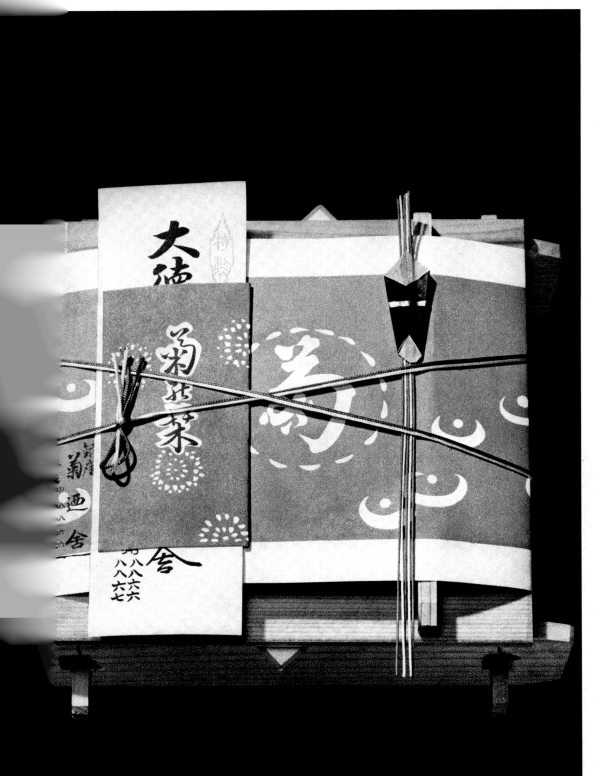

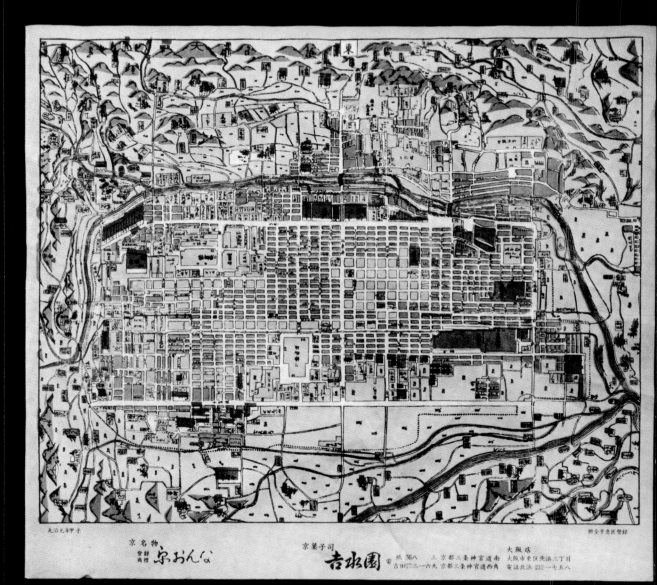

元治元年甲子 東 版全景意匠登録

京名物 京菓子司 大阪店
登録
商標 京おんな 吉水園 紙 随八 三 京都三条神宮道南 大阪市東区北浜三丁目
電 吉田町三一六九 京都三条神宮道西角 電話北浜（231）一七五八

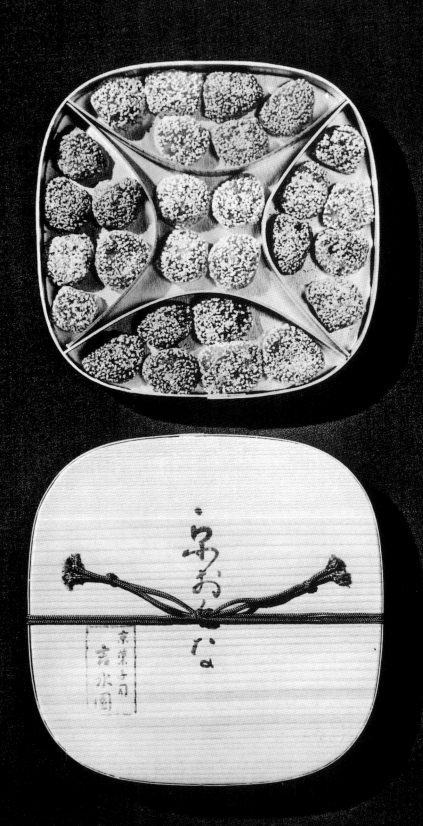

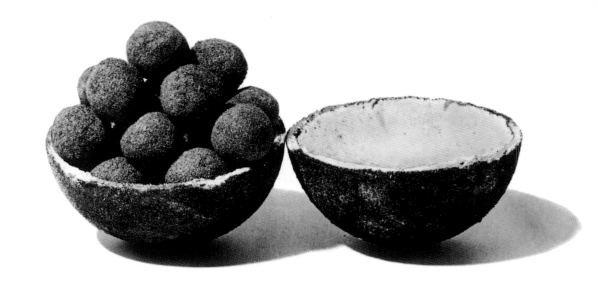

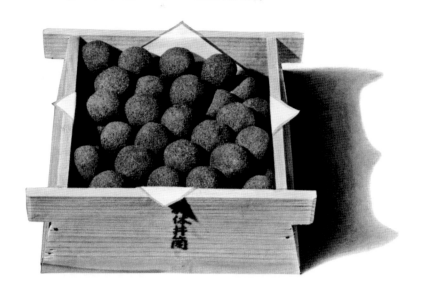

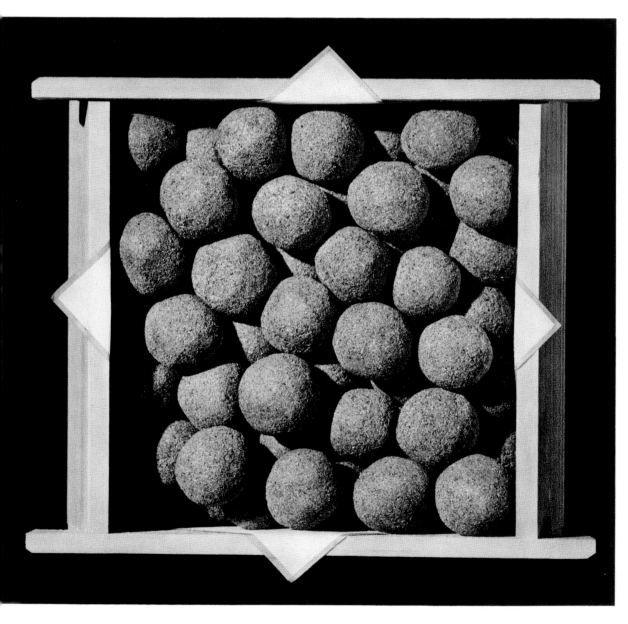

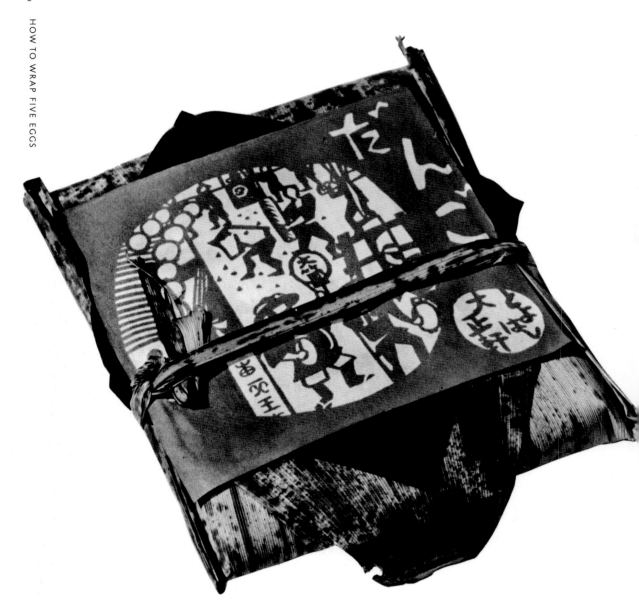

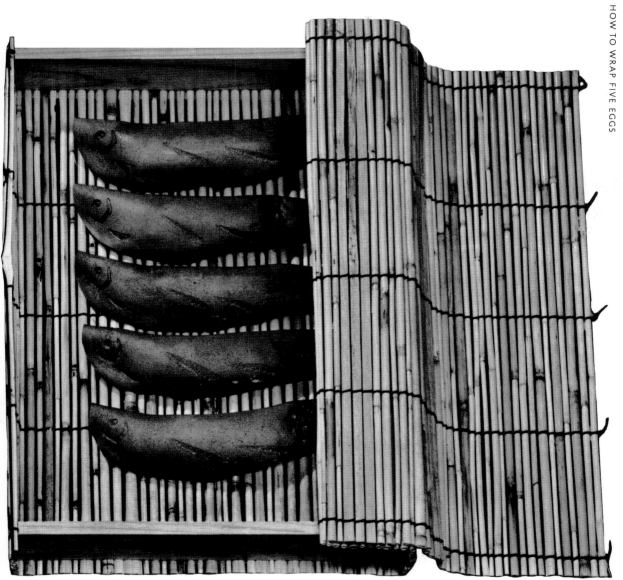

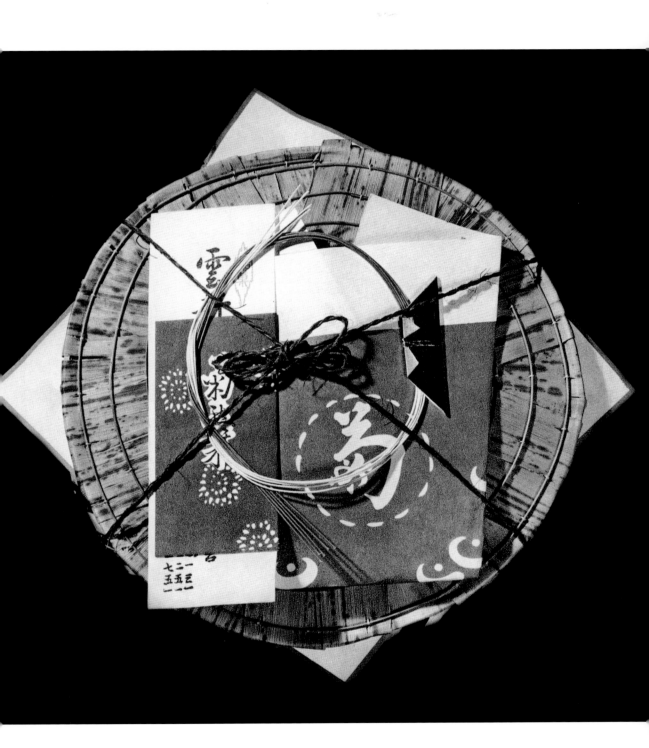

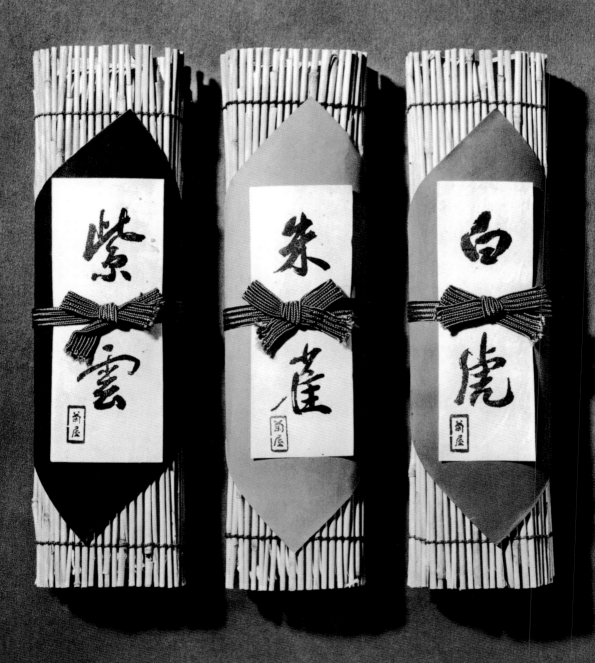

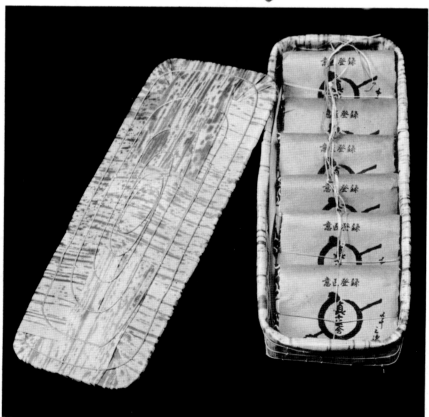

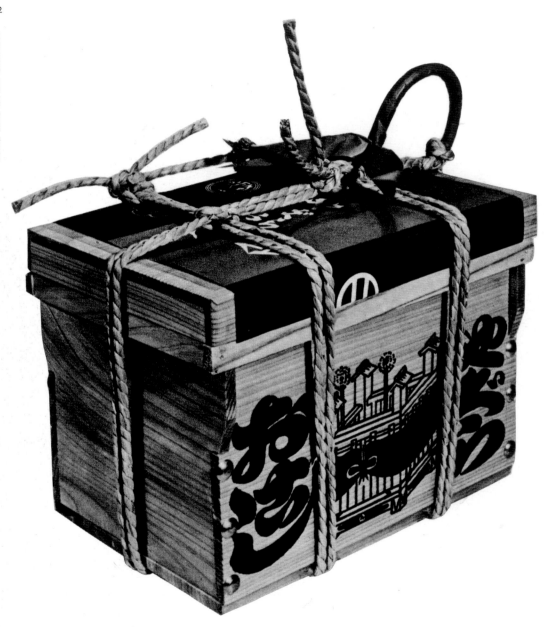

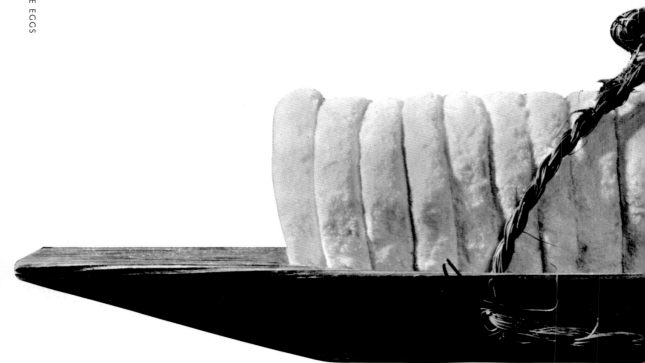

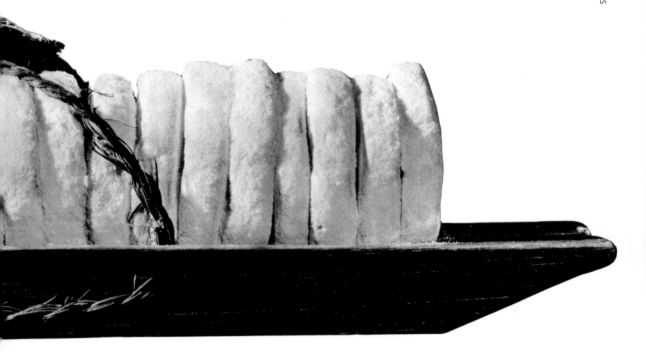

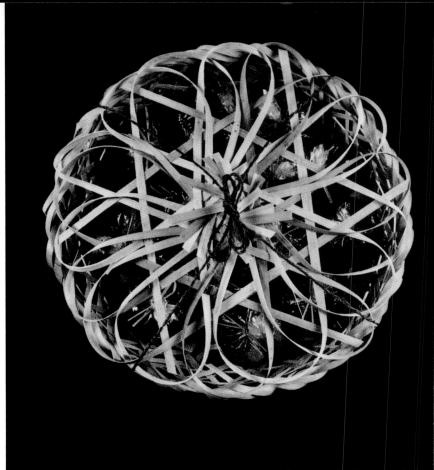

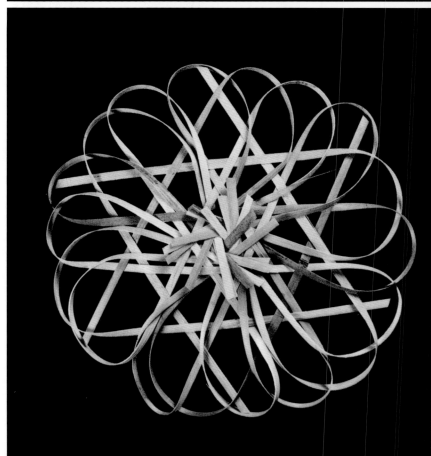

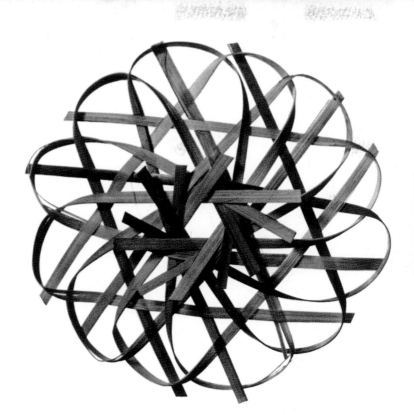
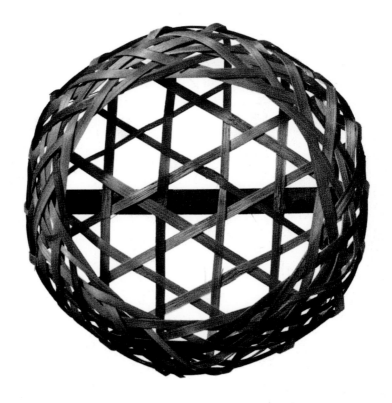

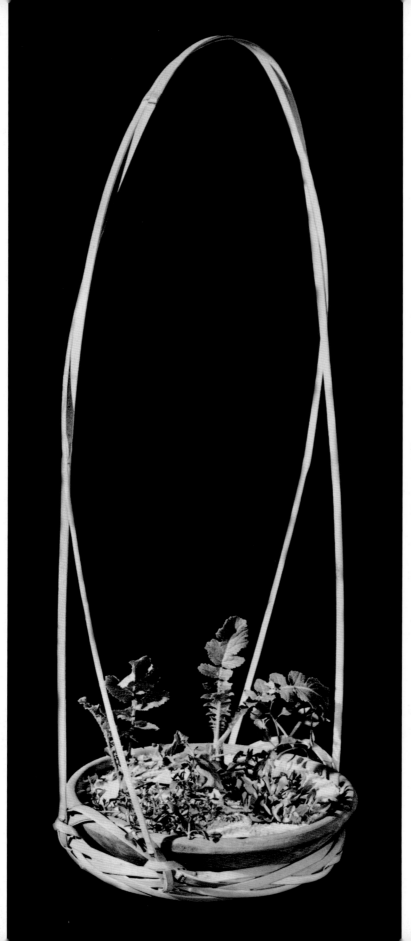

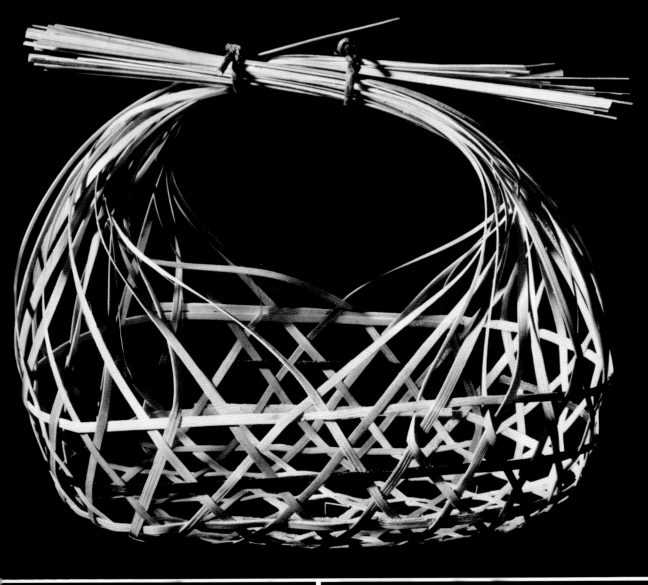
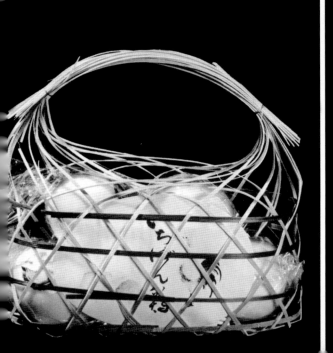
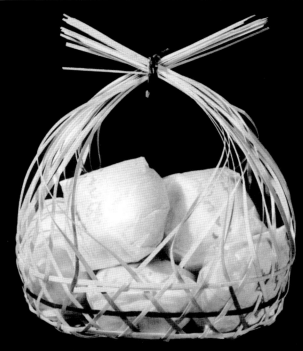

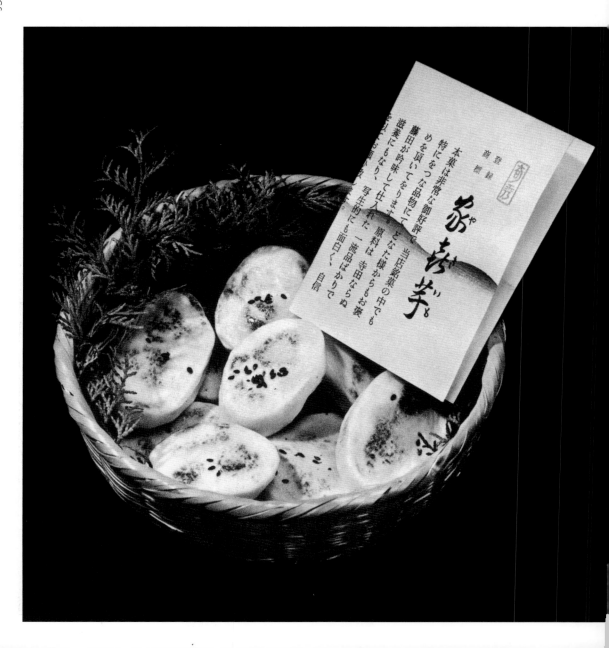

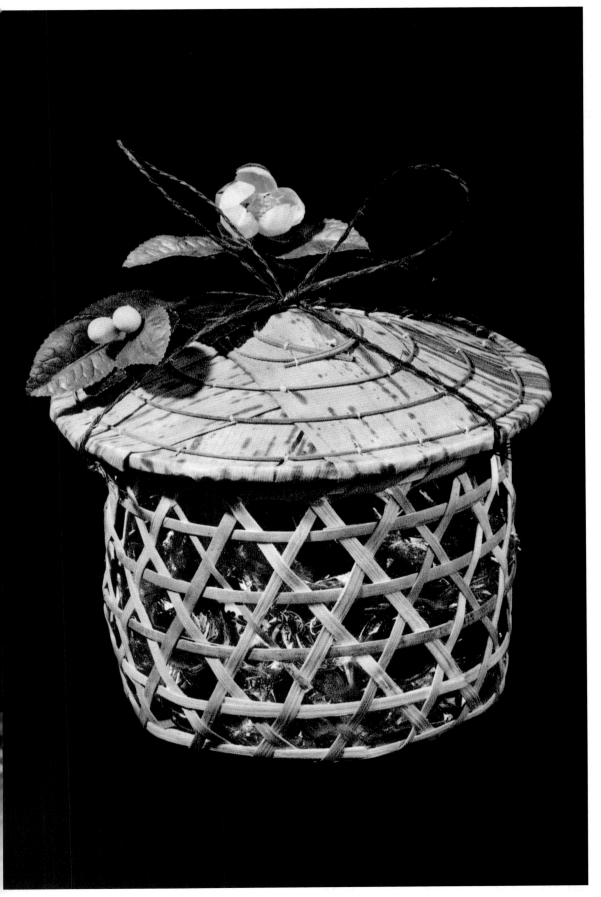

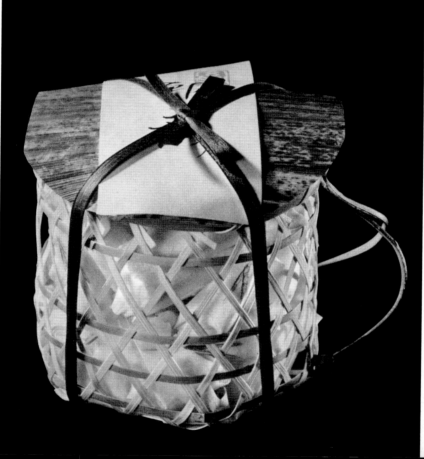

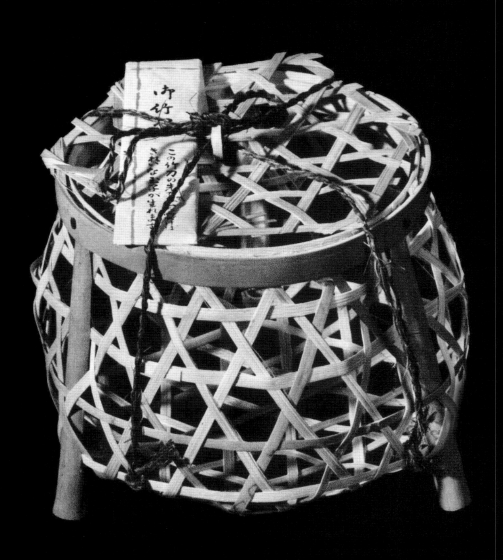

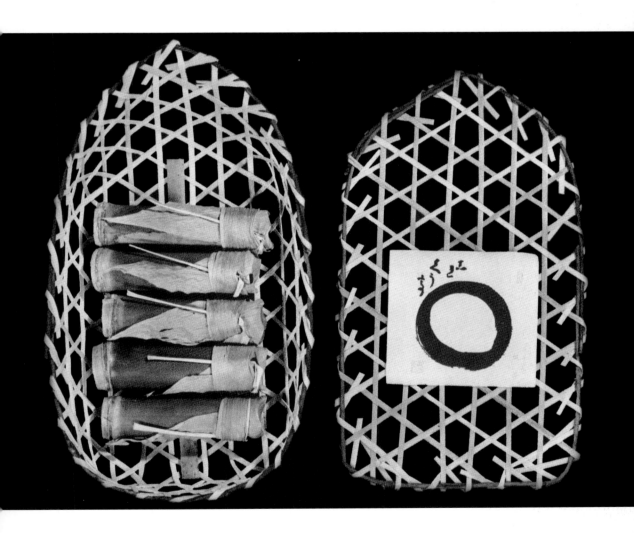

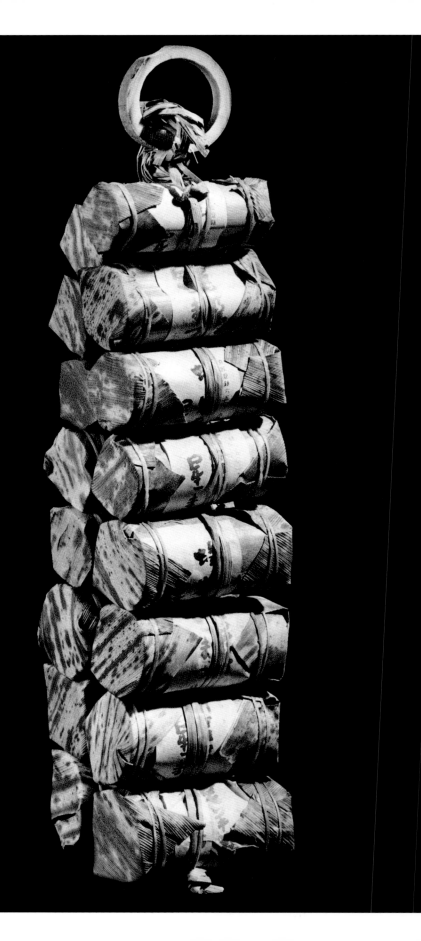

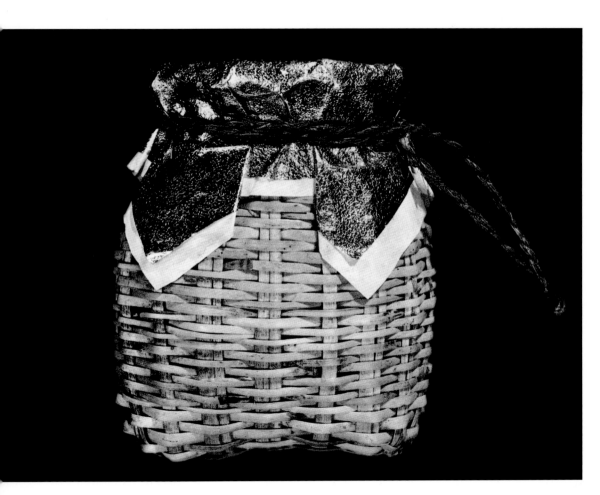

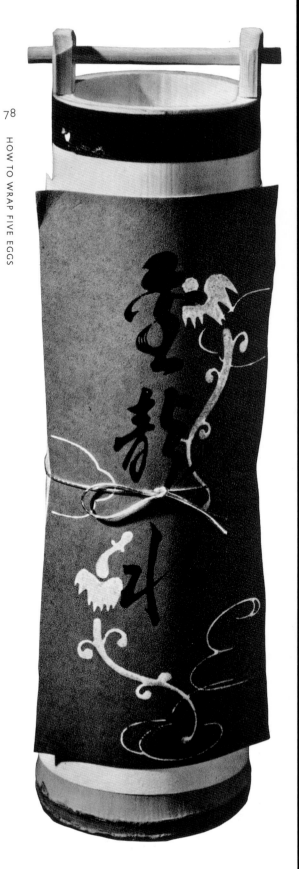

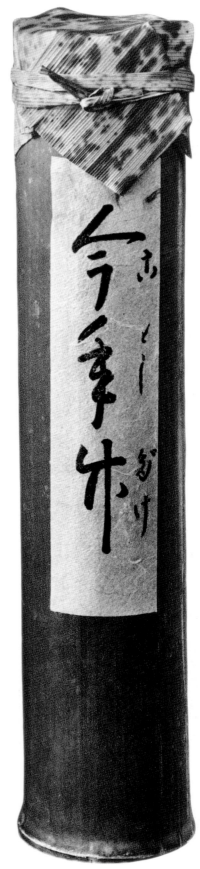

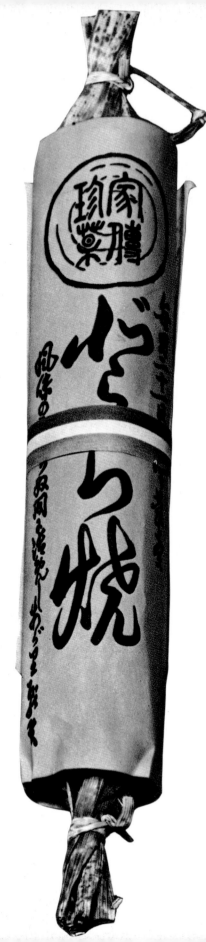
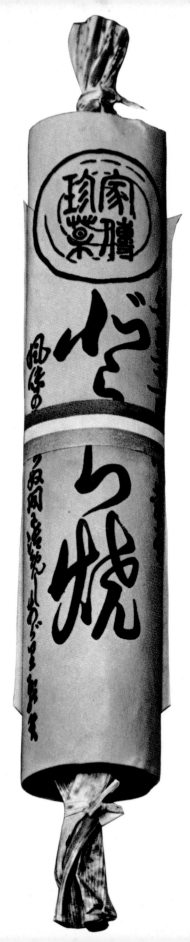

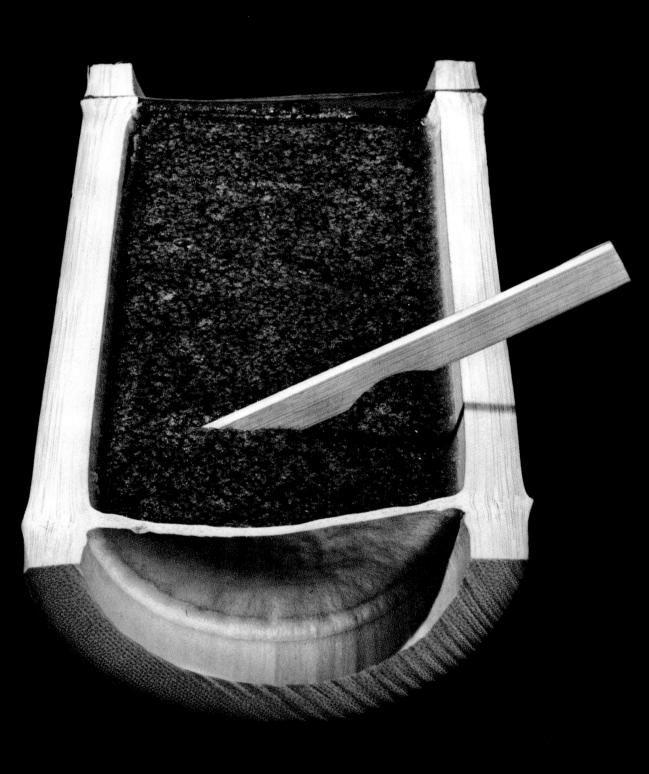

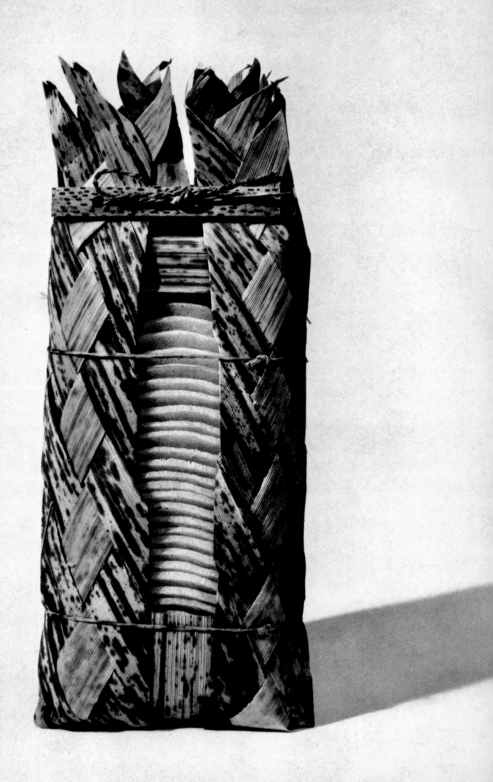

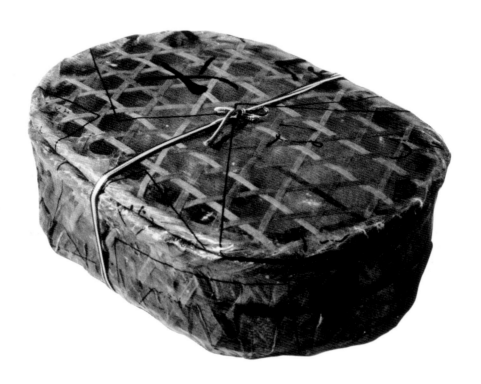

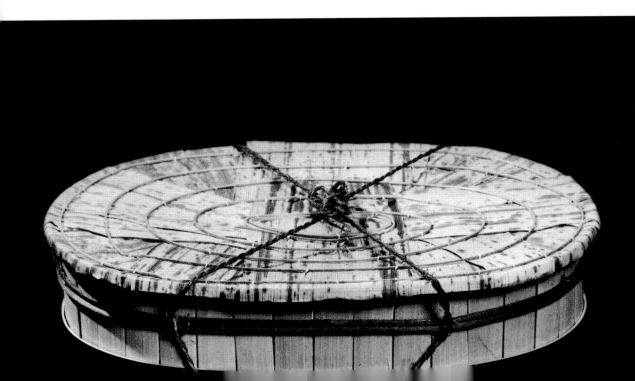

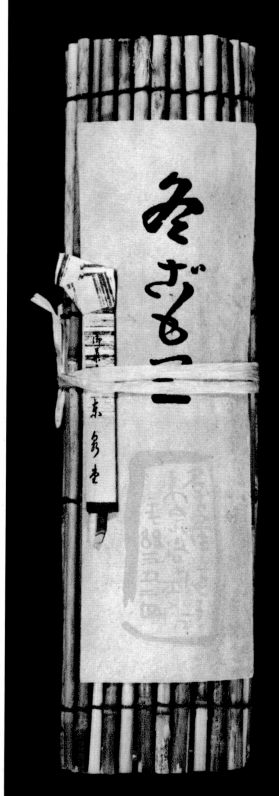
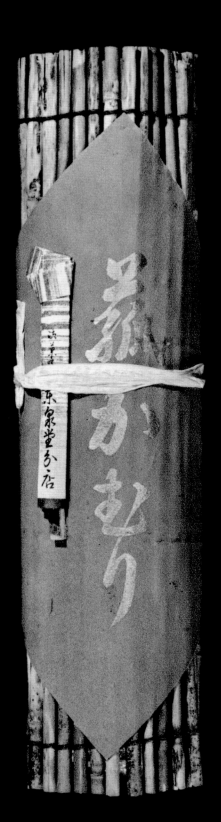

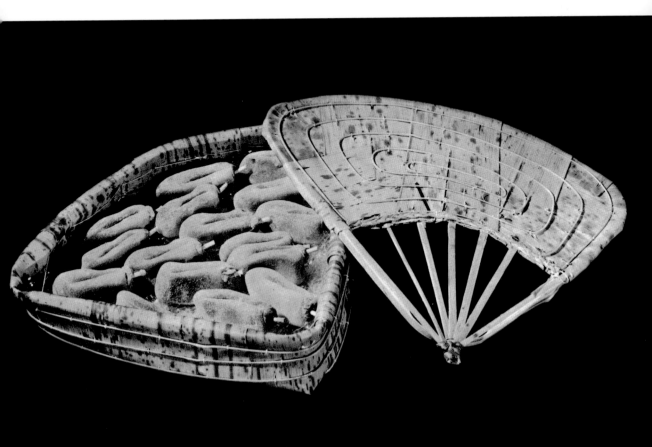

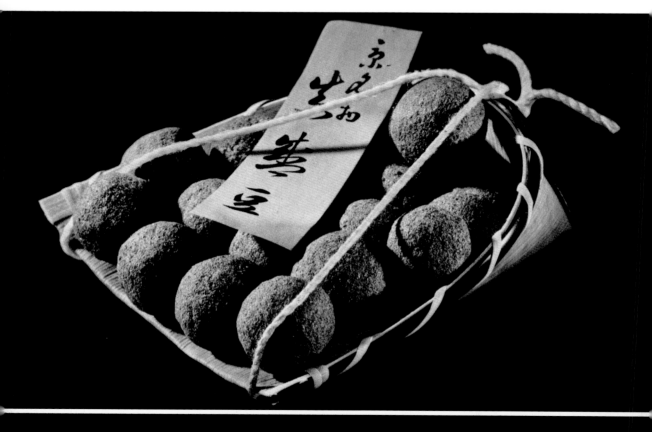

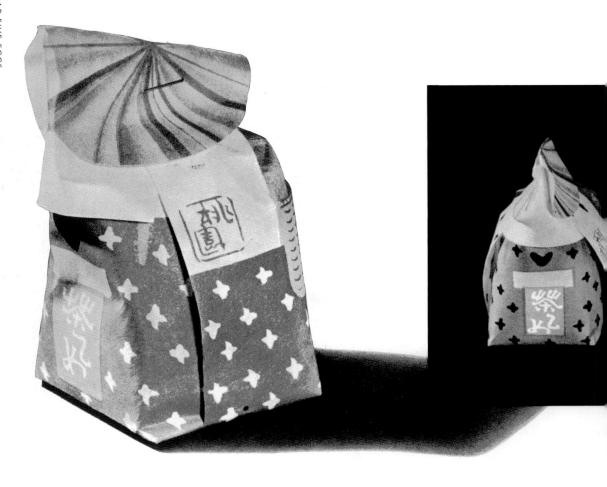

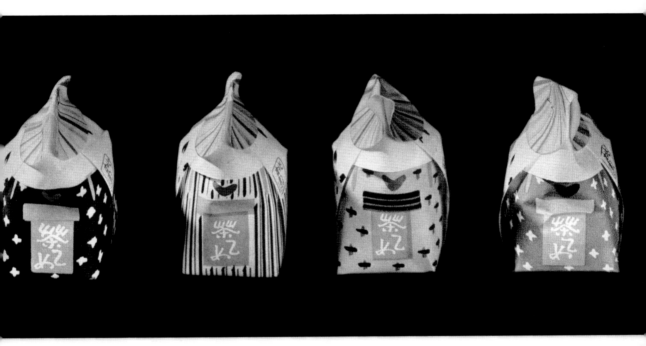

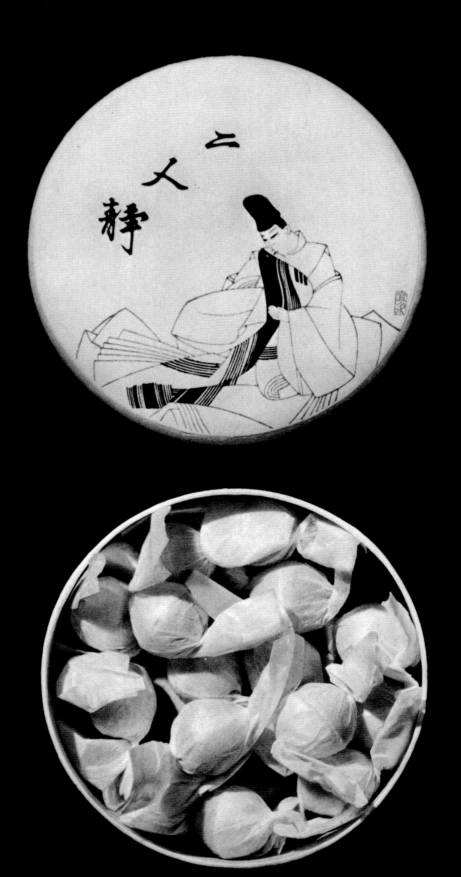

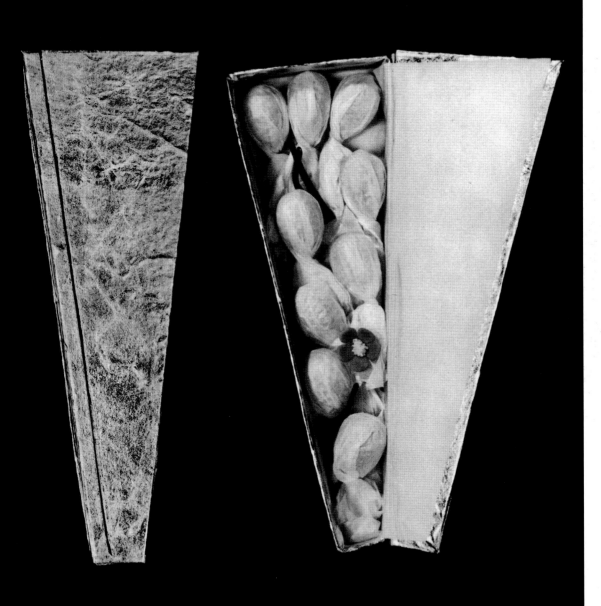

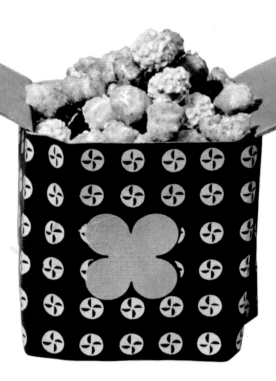

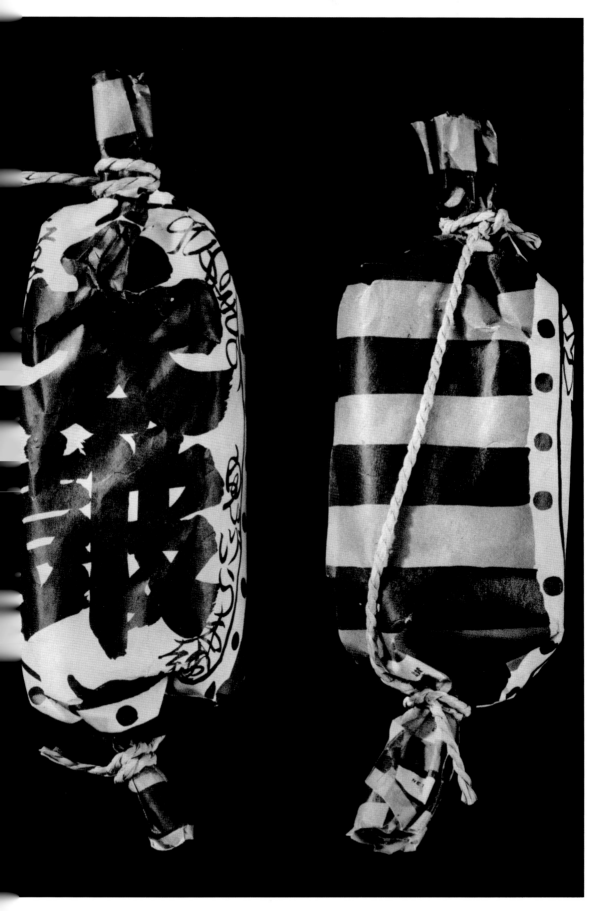

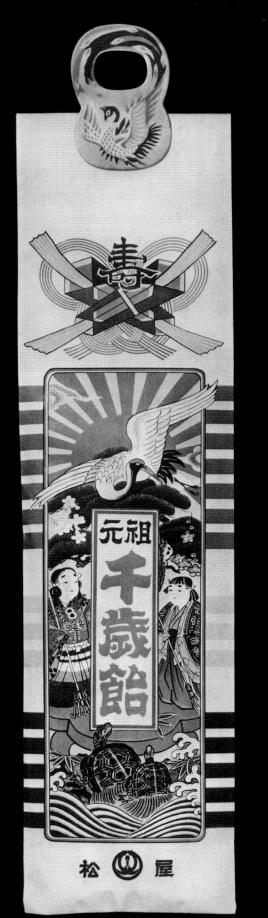
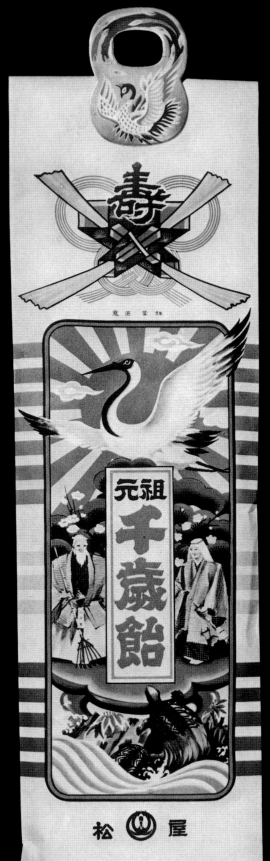

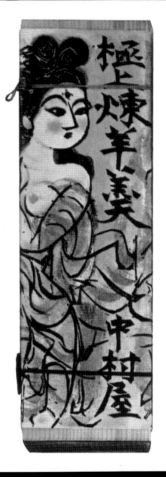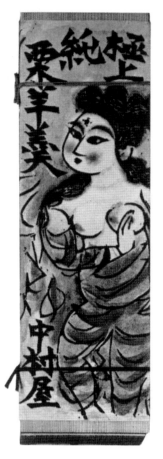

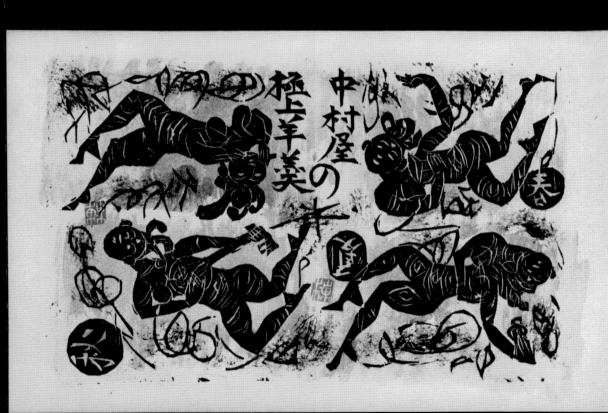

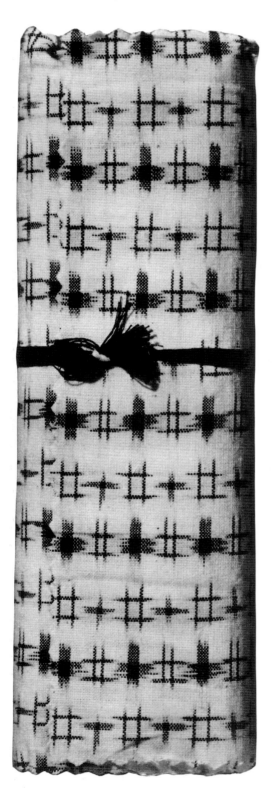

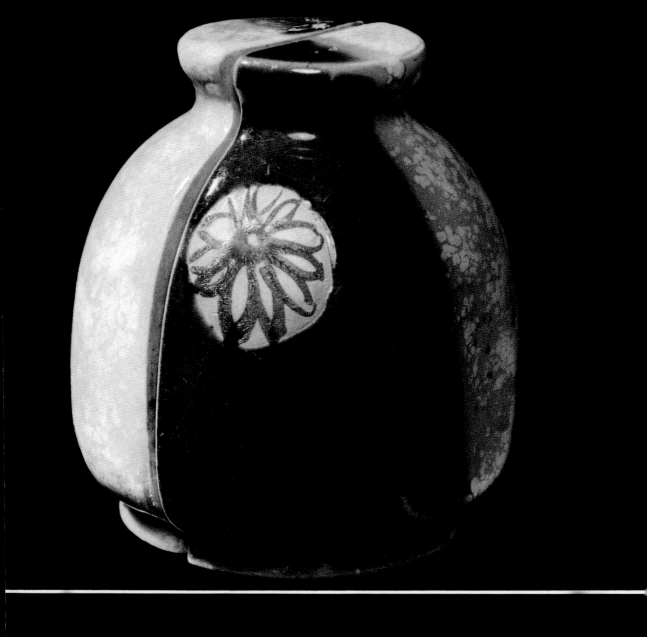
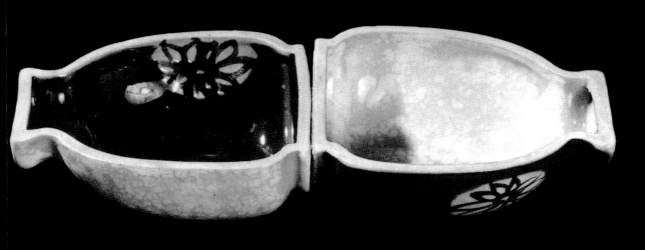

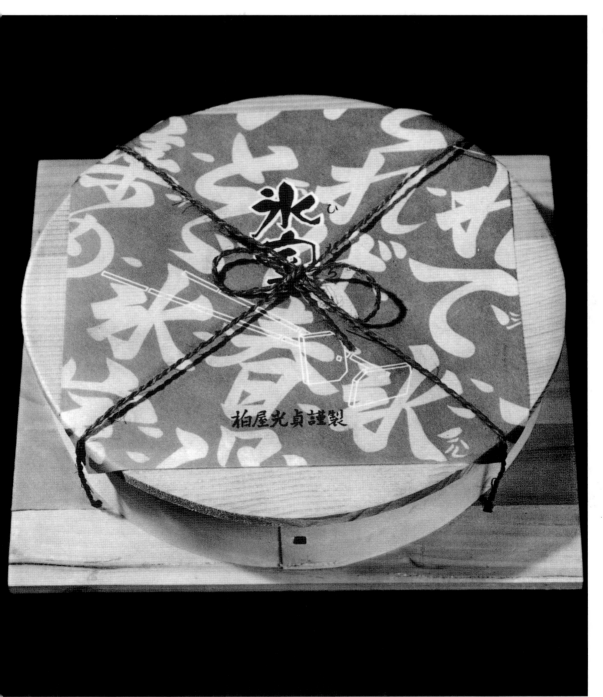

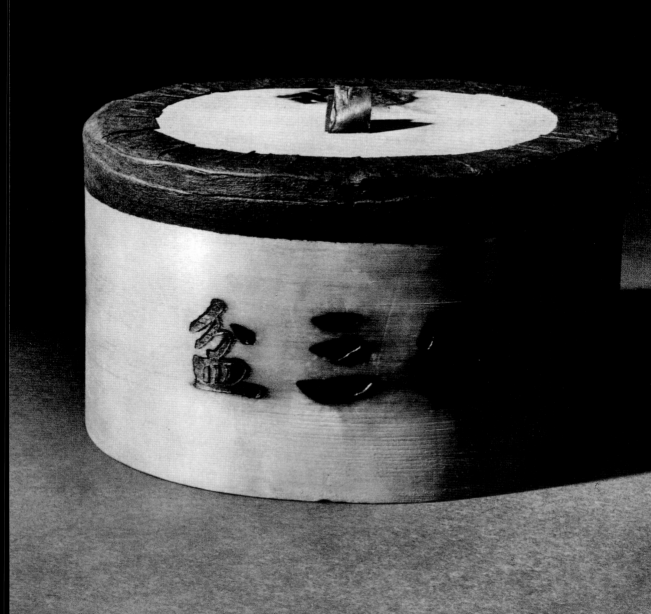

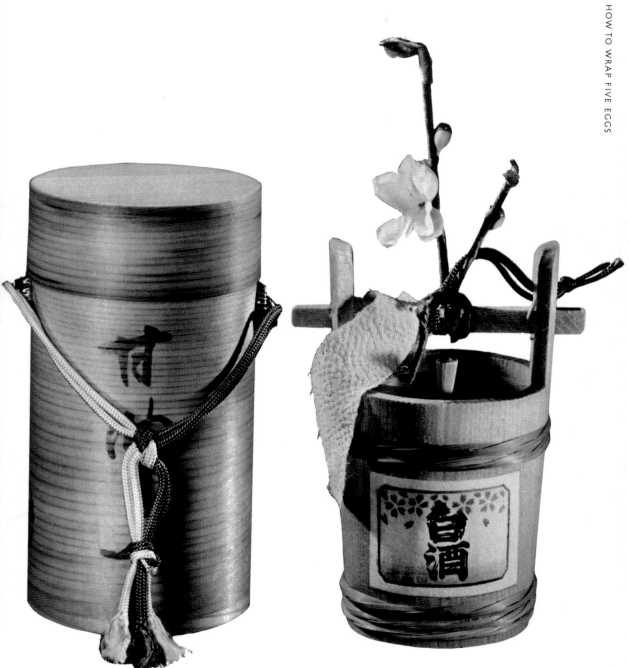

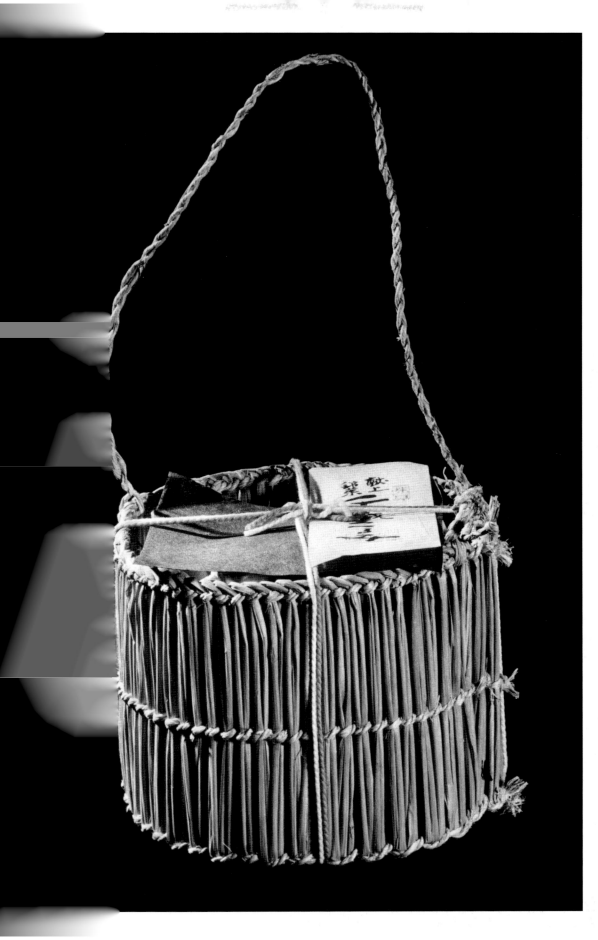

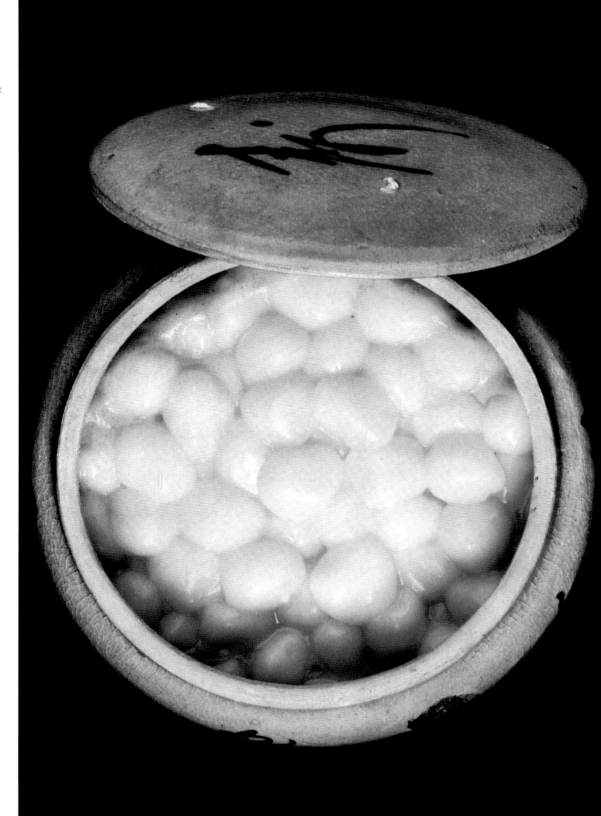

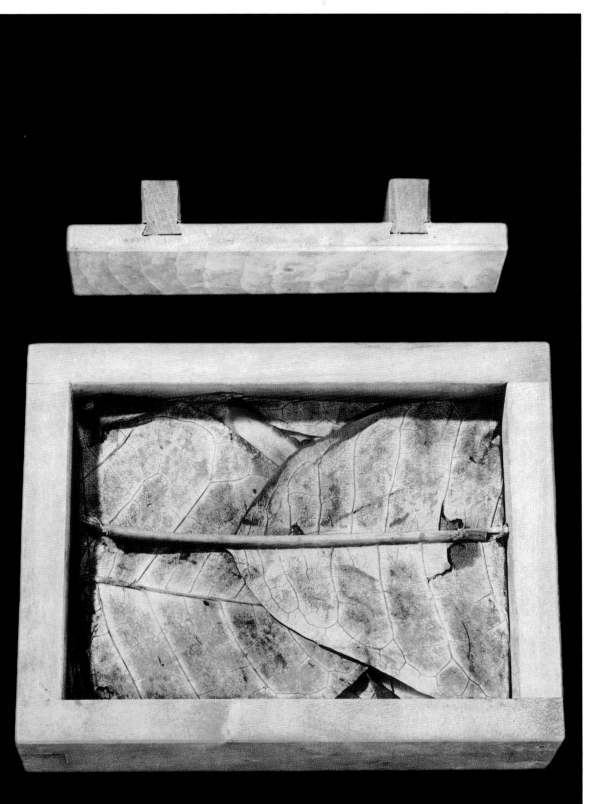

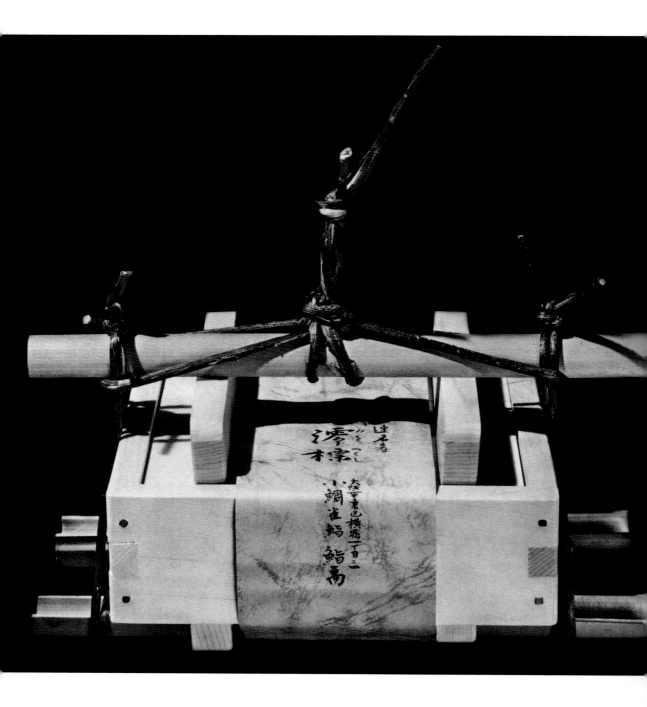

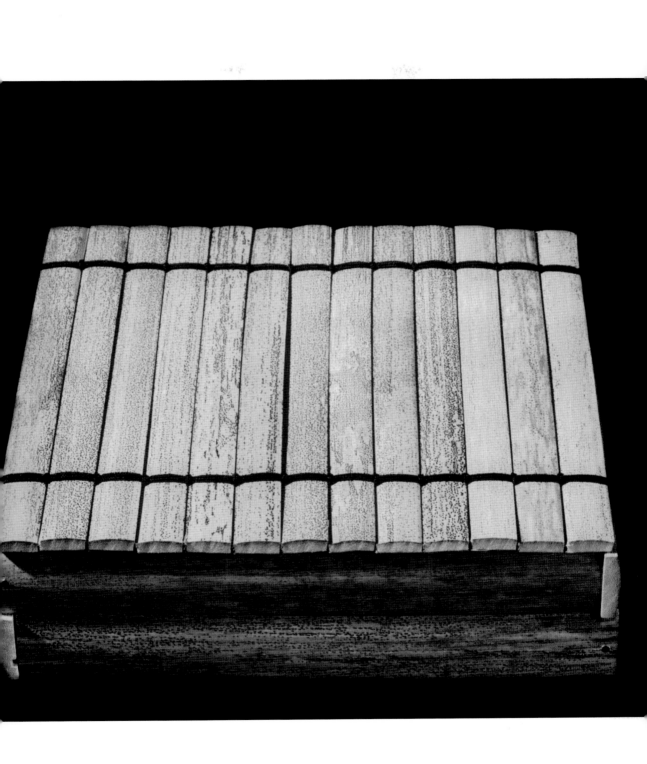

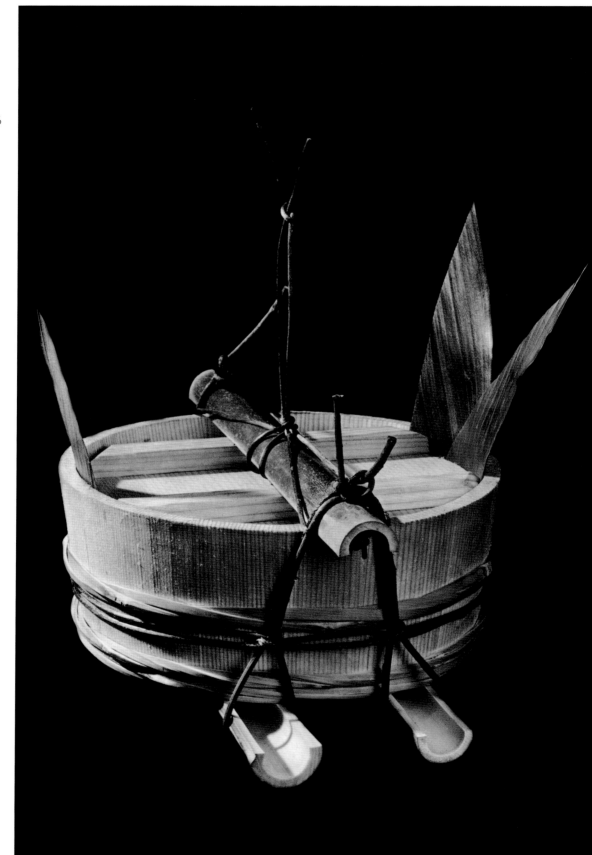

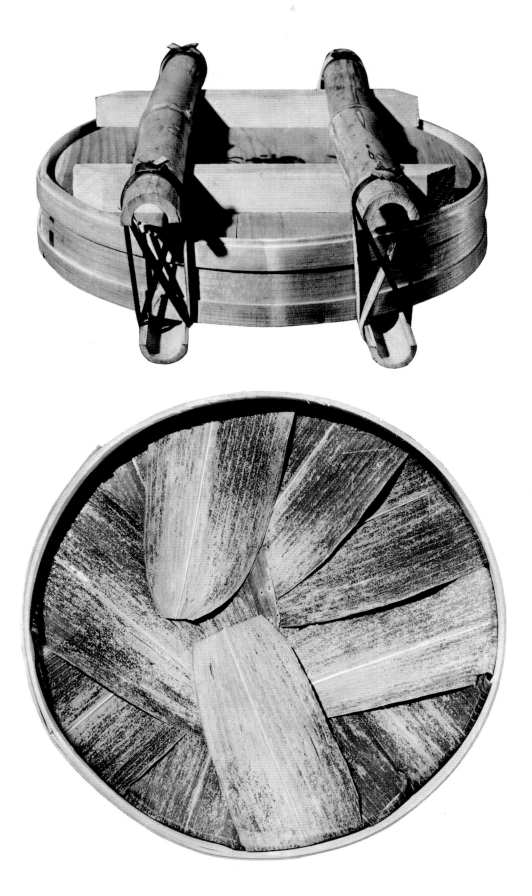

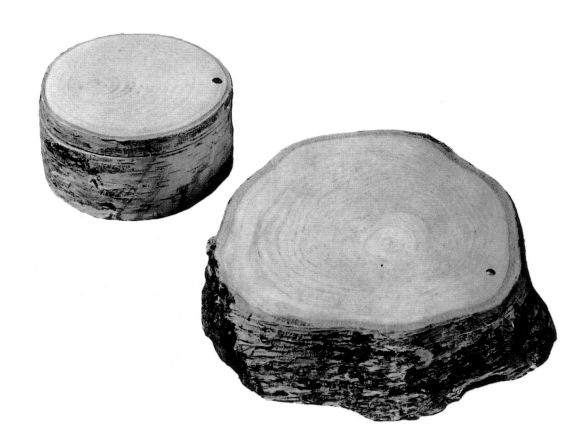

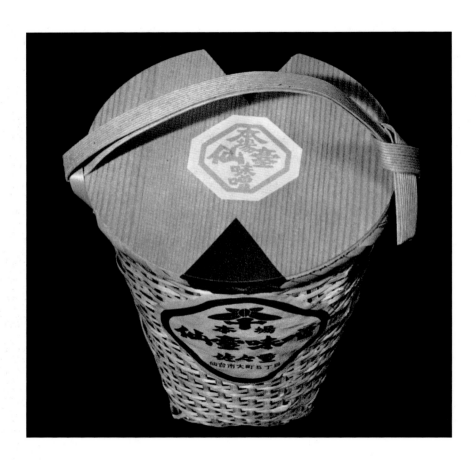

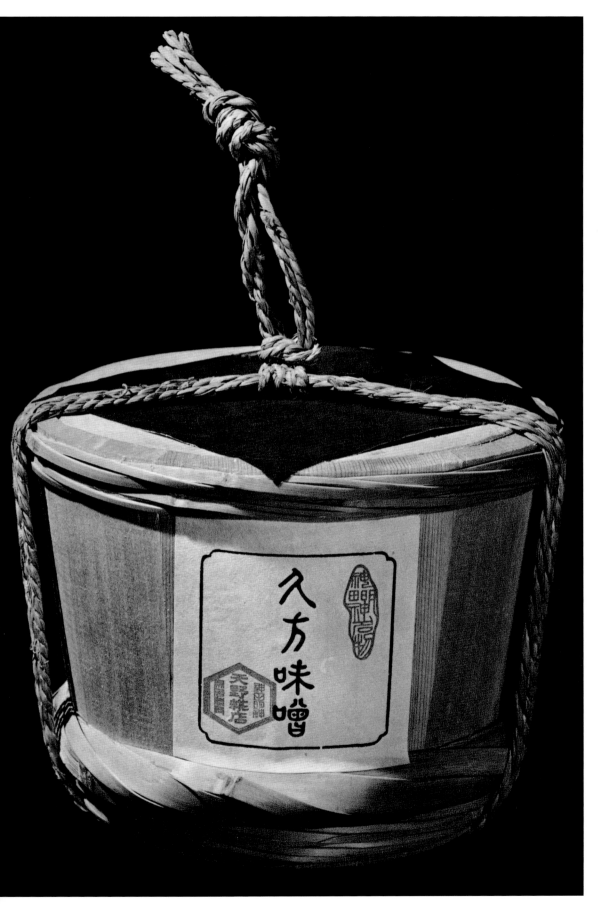

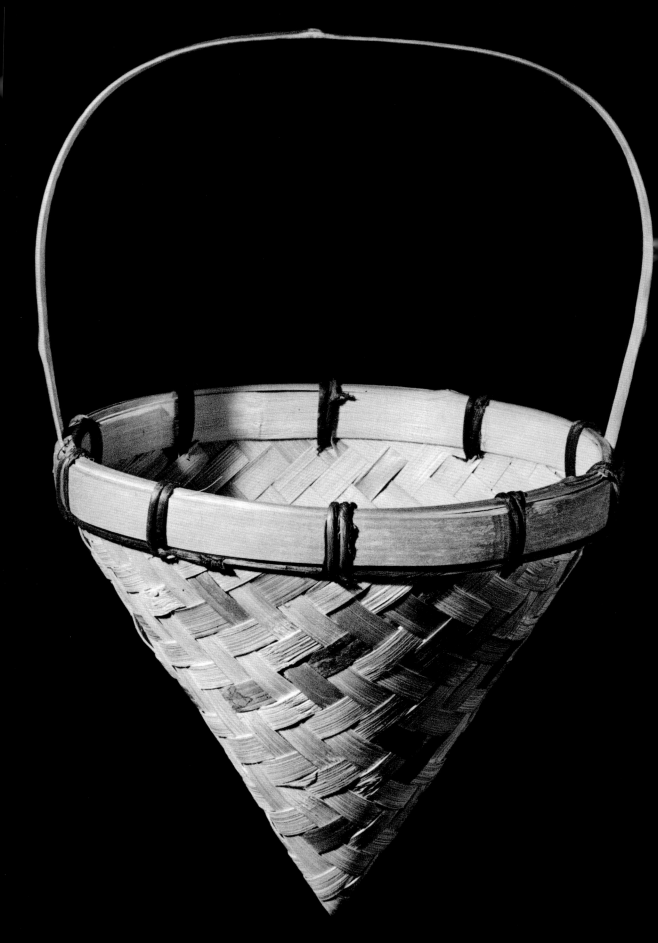

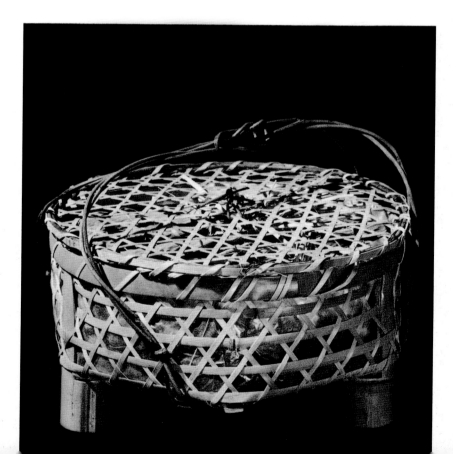

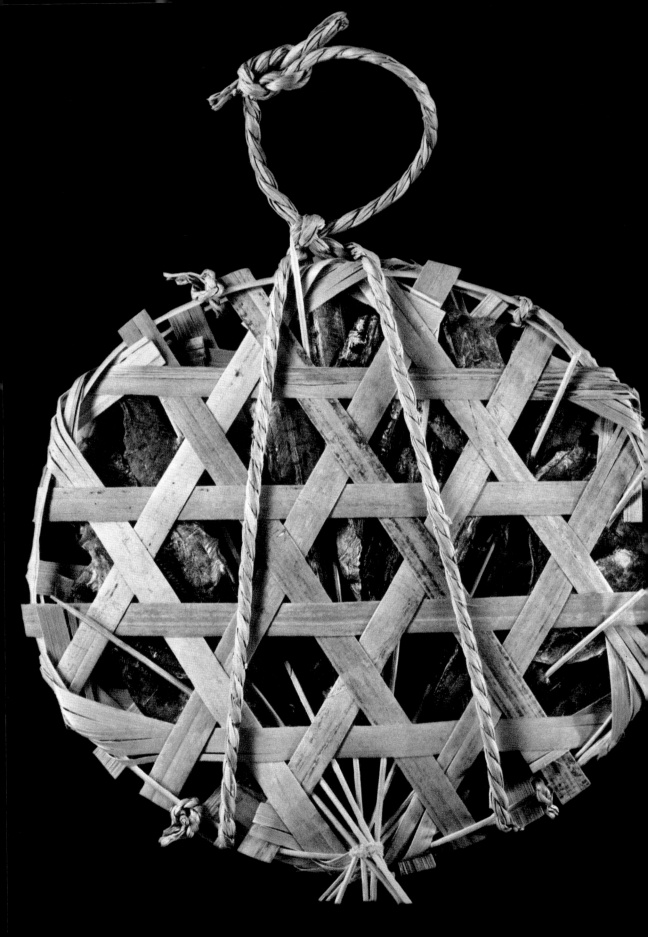

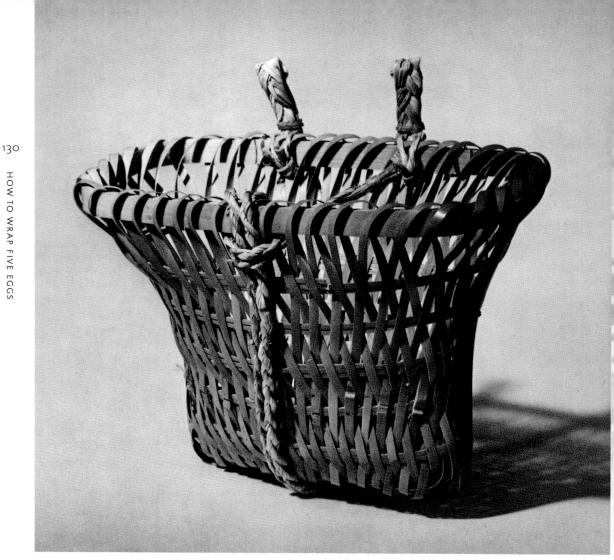

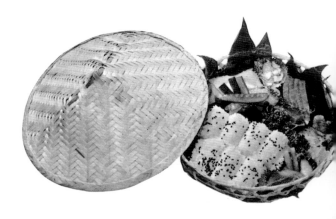

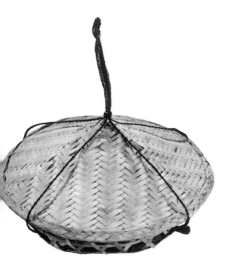

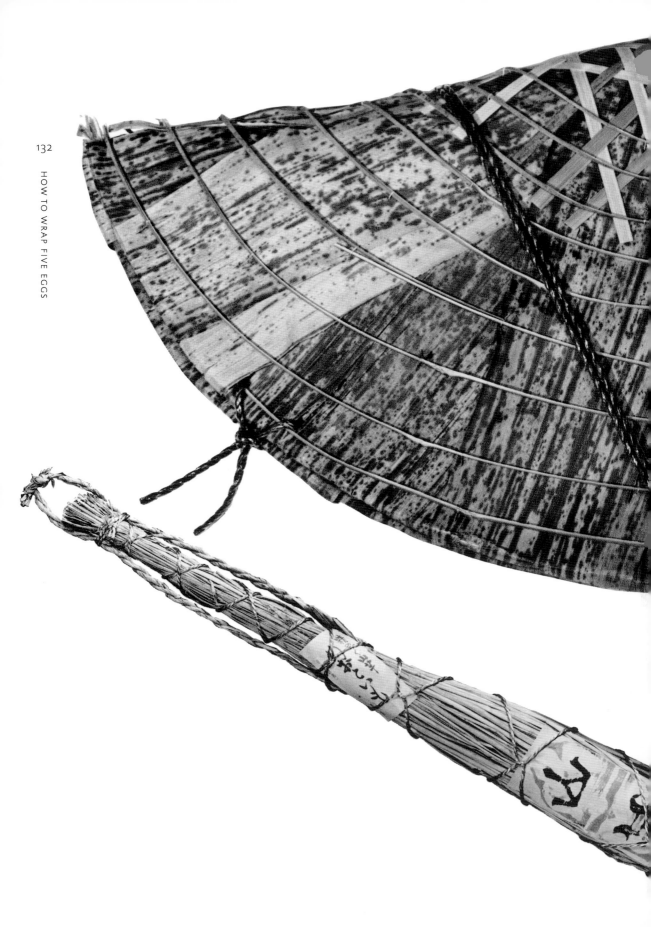

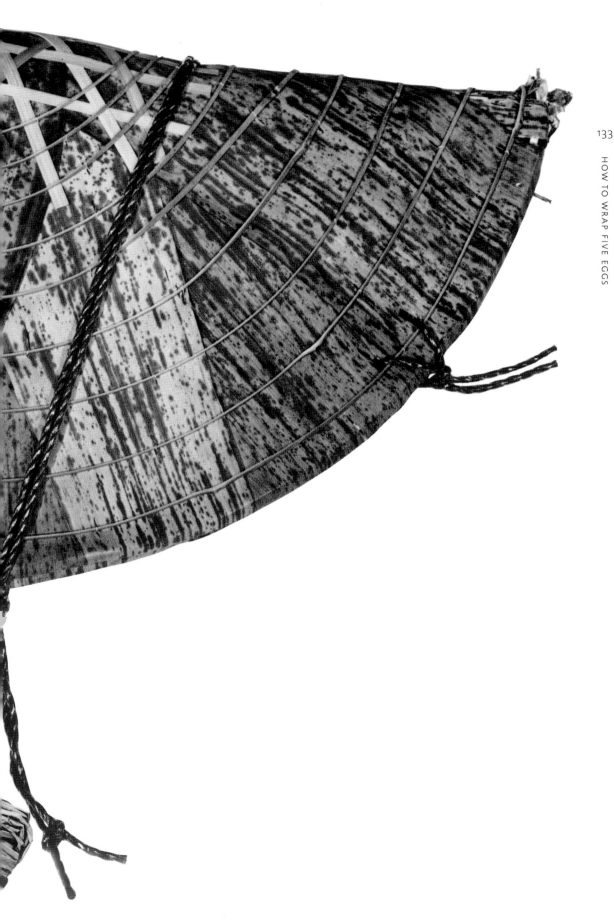

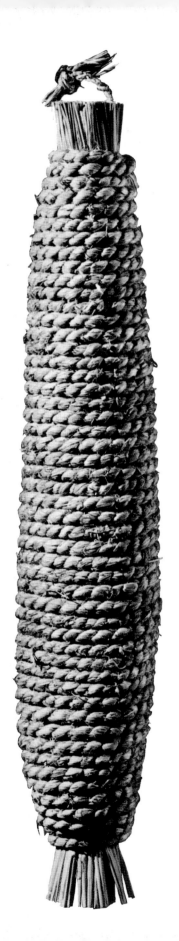
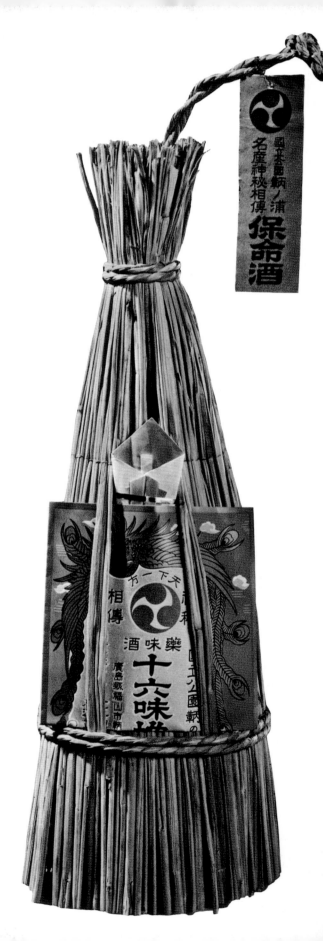

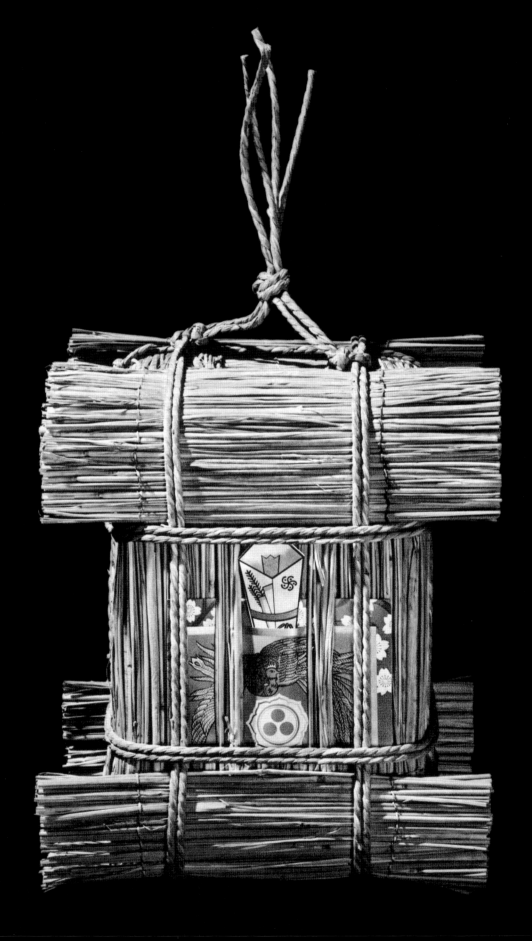

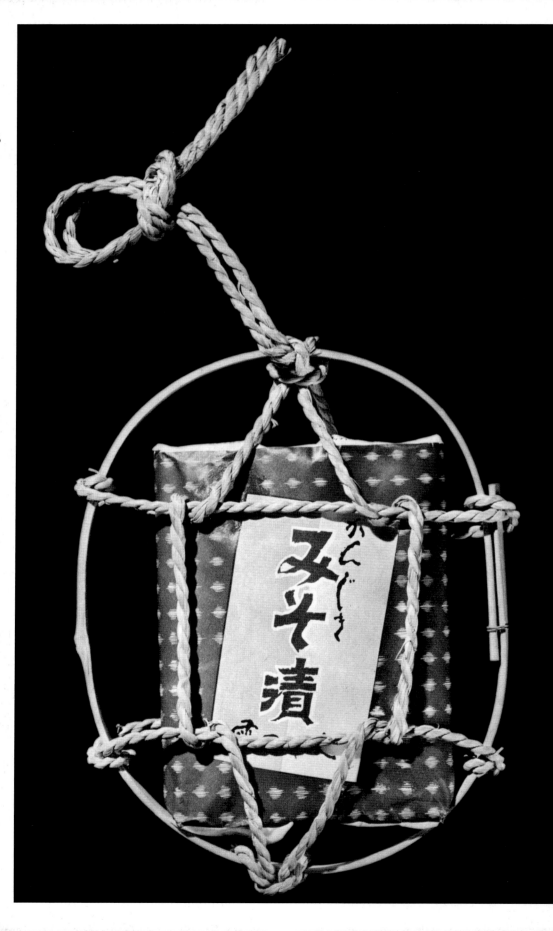

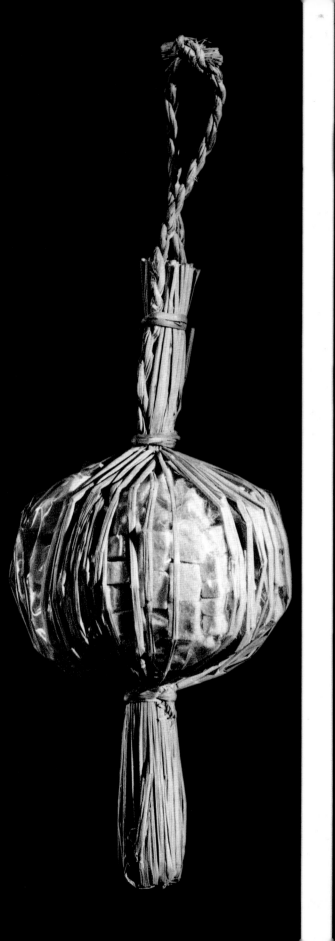
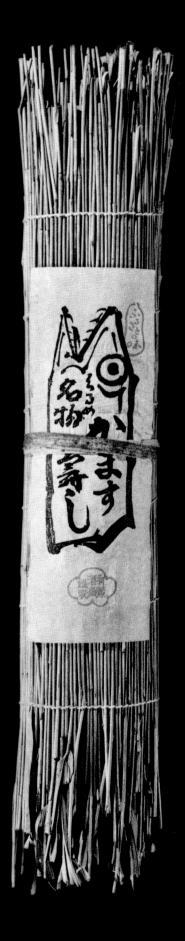

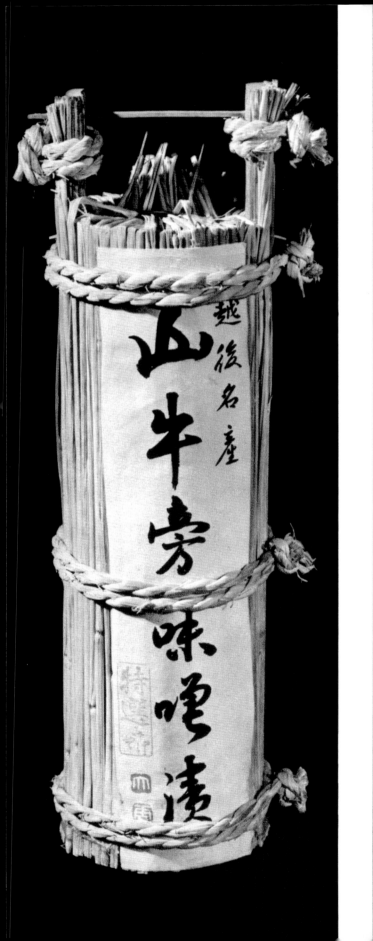
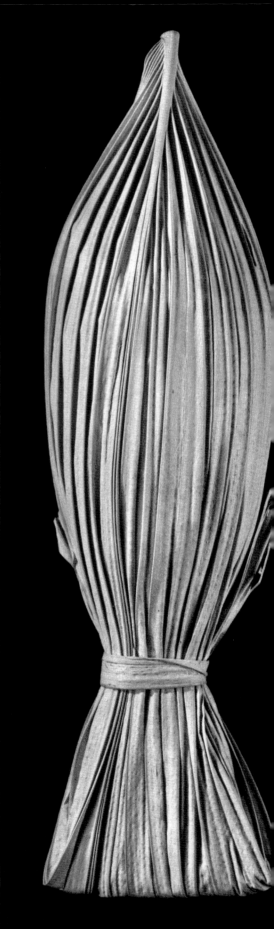

越後名産

山牛蒡味噌漬

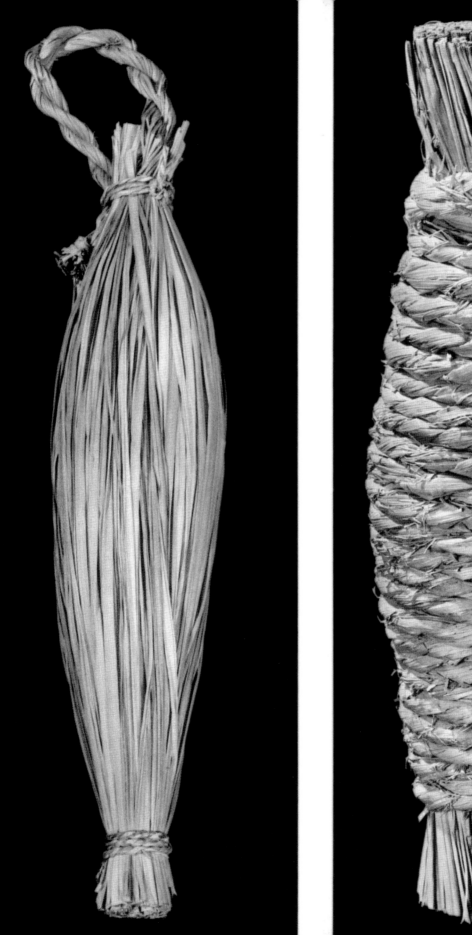

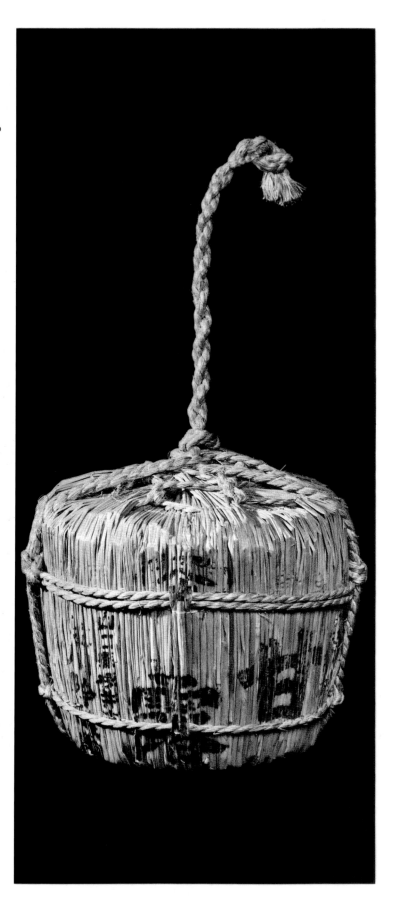

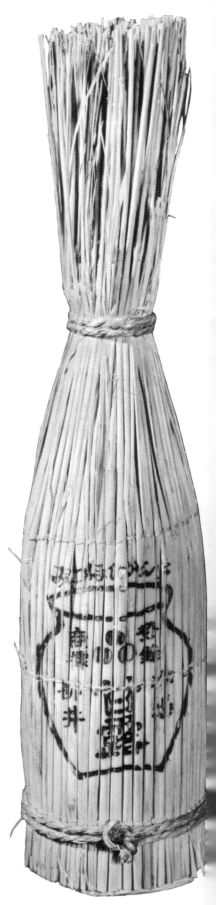

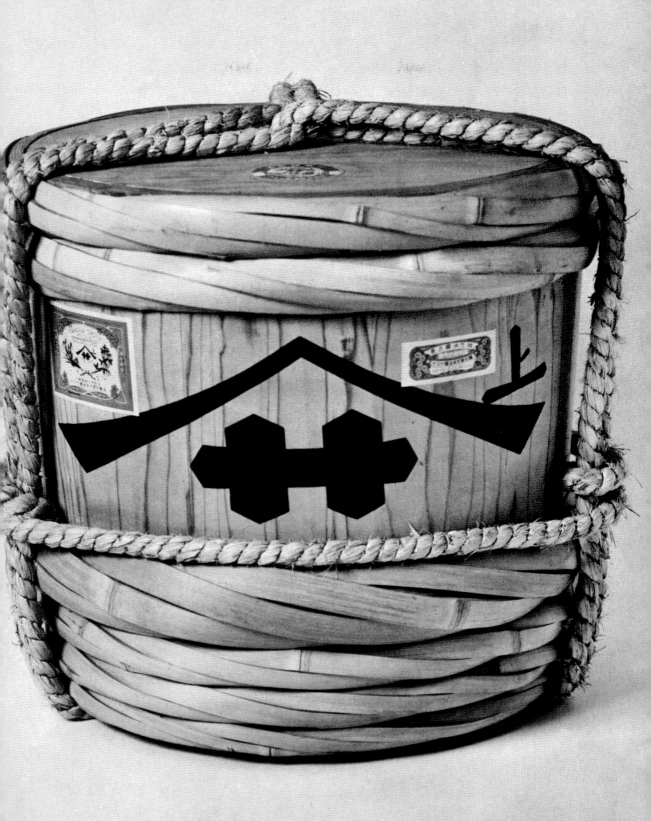

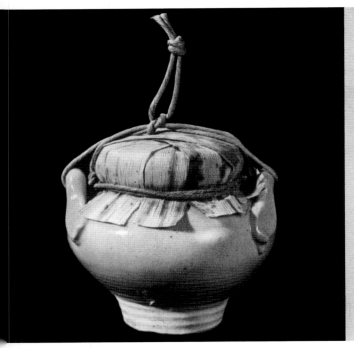
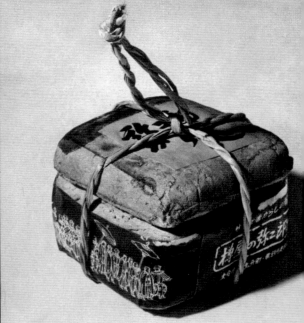

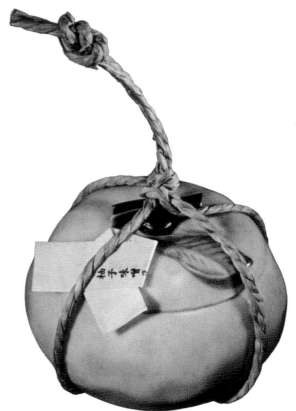

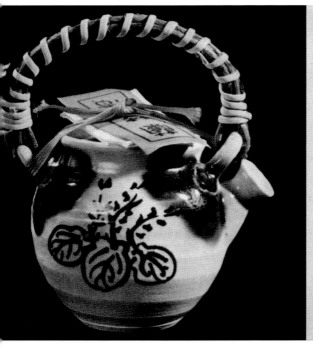

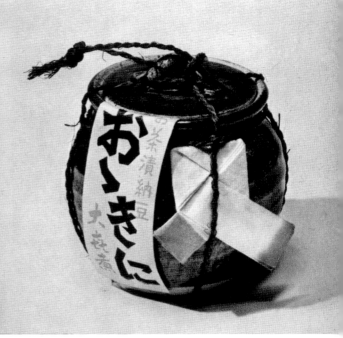

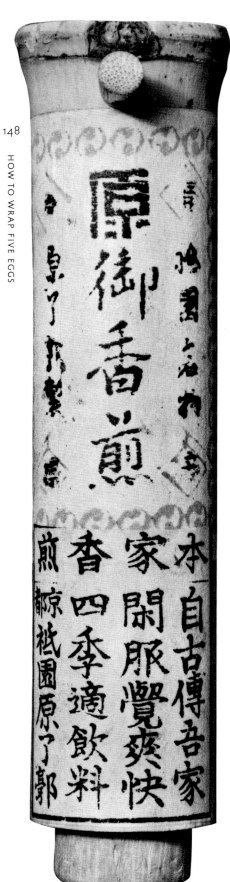
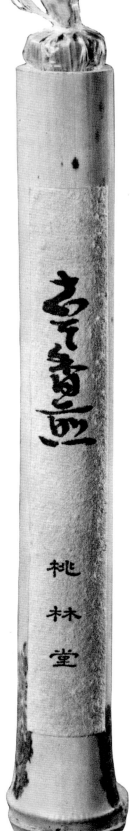
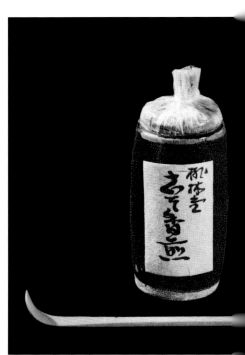

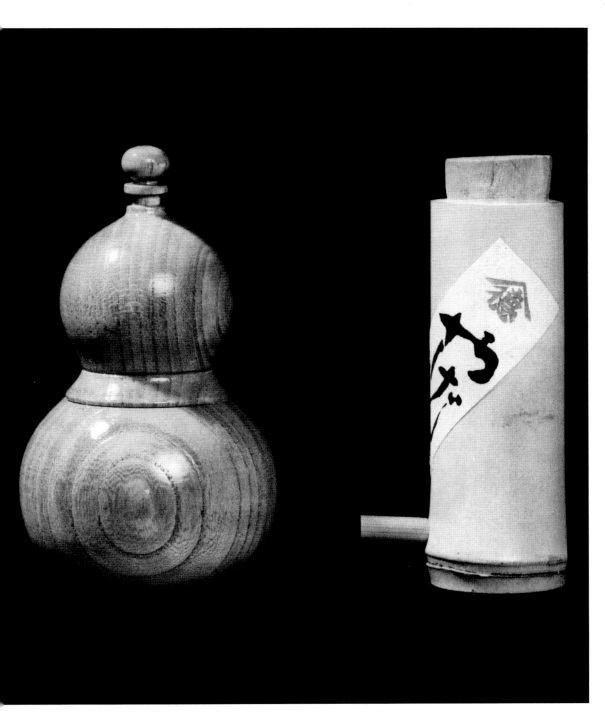

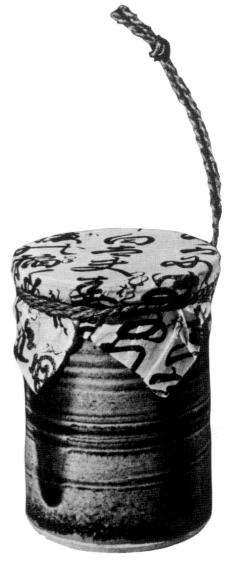

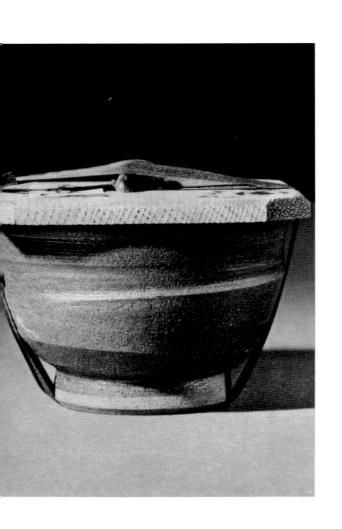

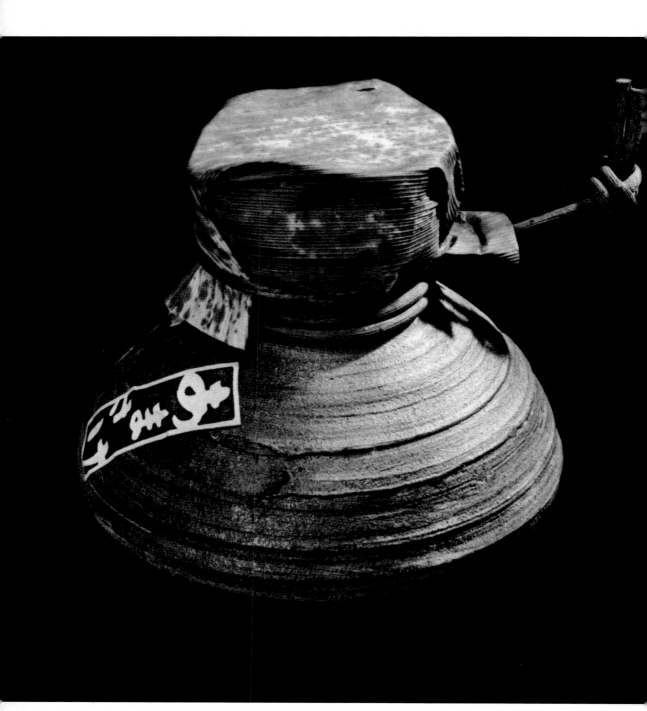

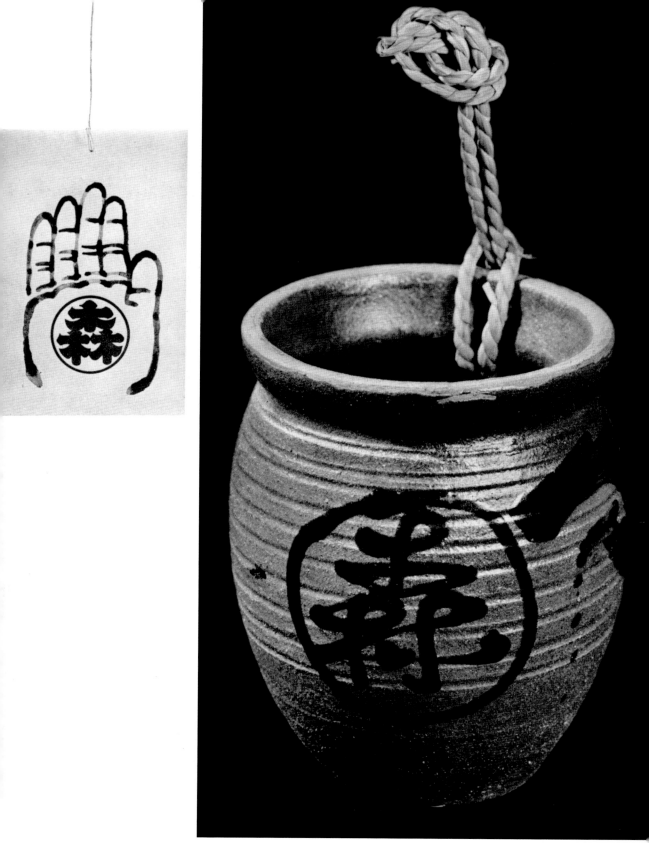

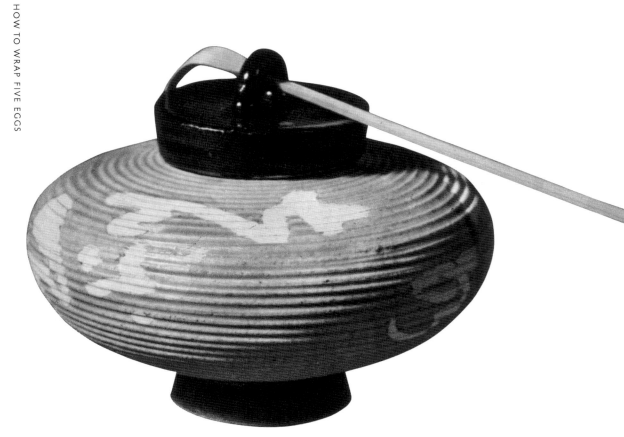

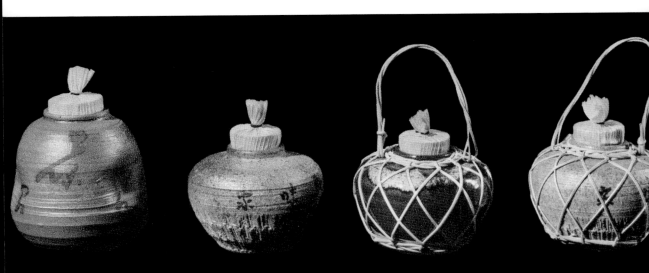

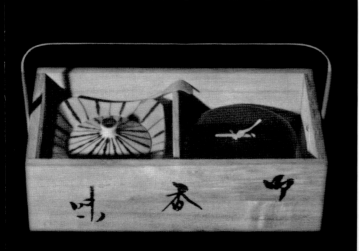
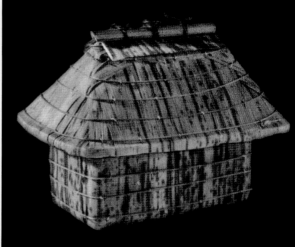

秋田名産

佐竹御藩主用

稲庭干饂飩

稲庭干饂飩製造元

稲庭 町

稲庭吉左衛門

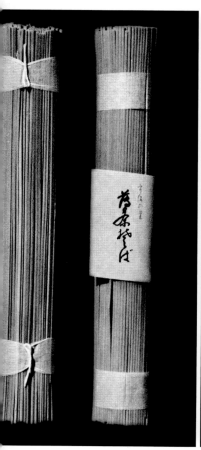

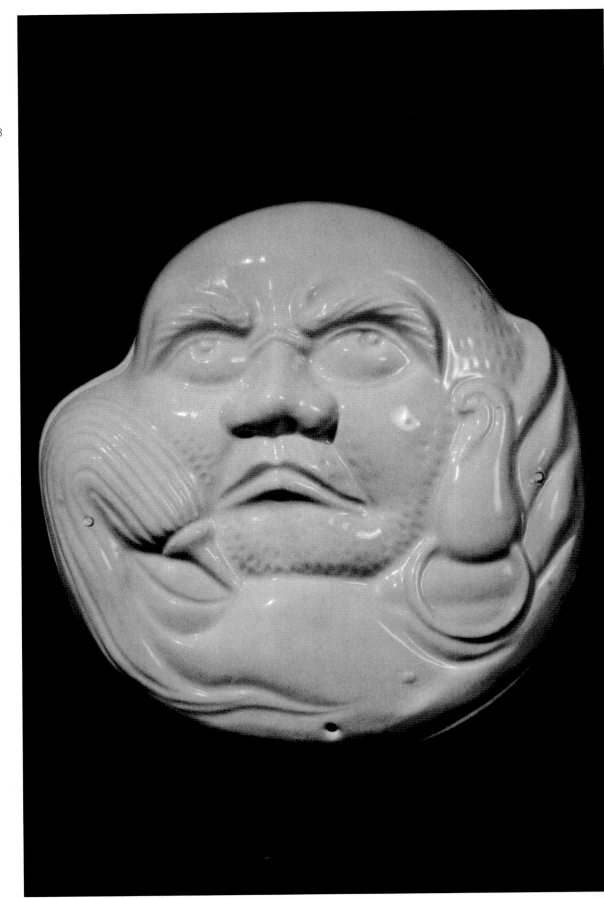

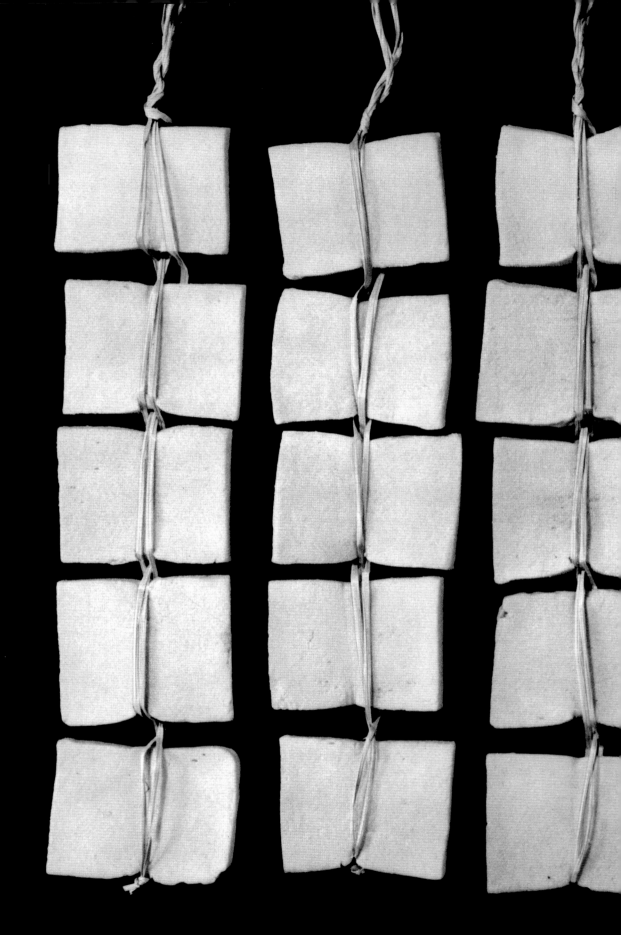

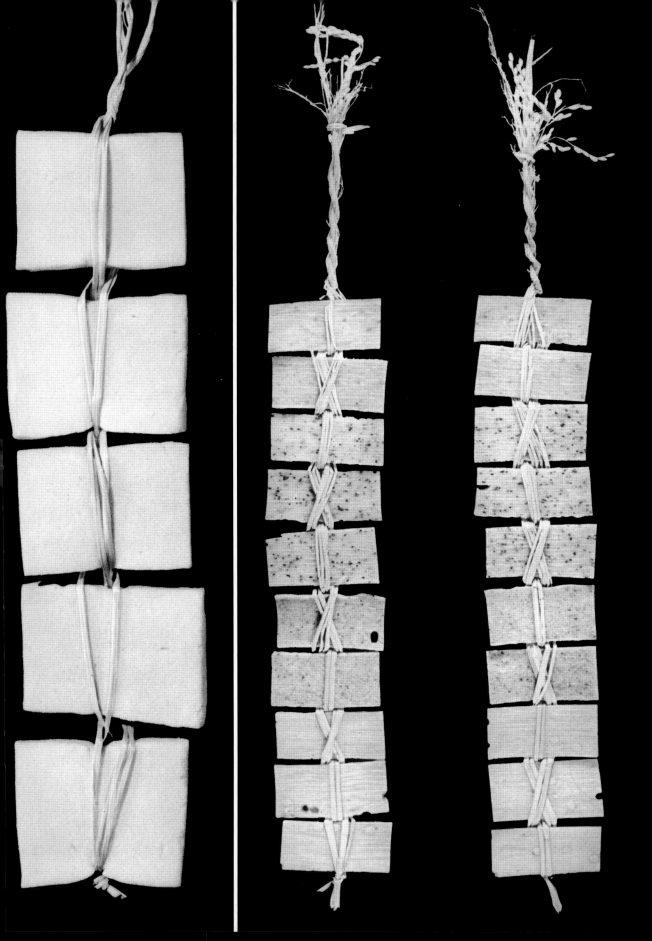

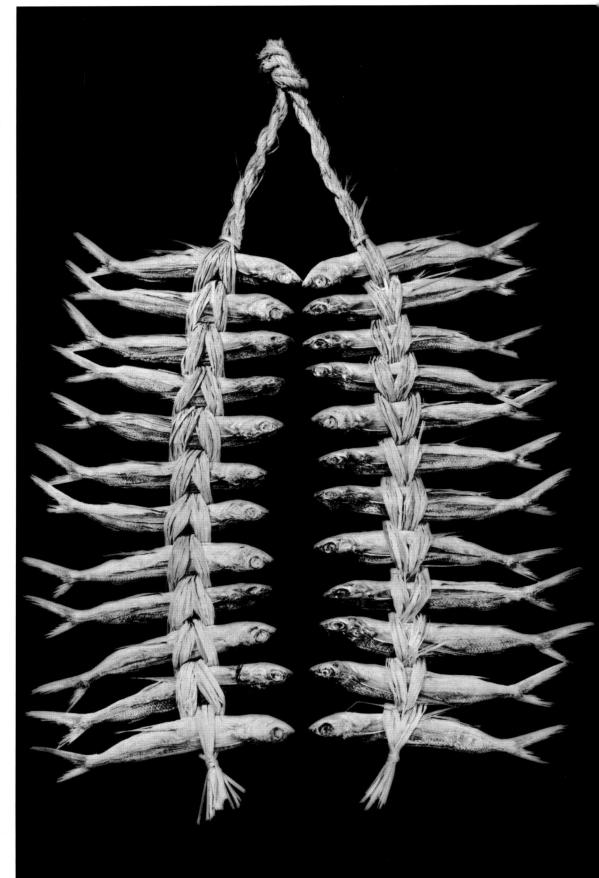

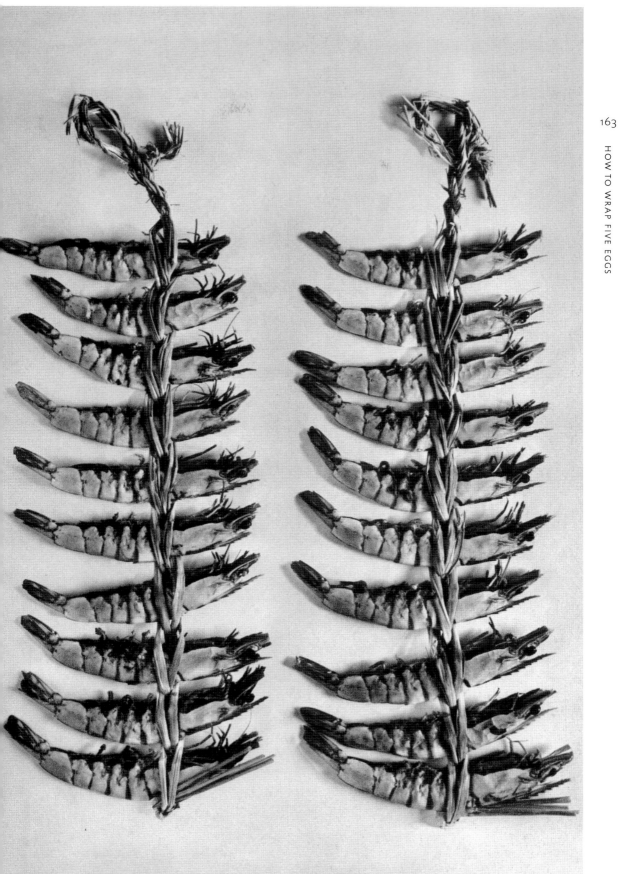

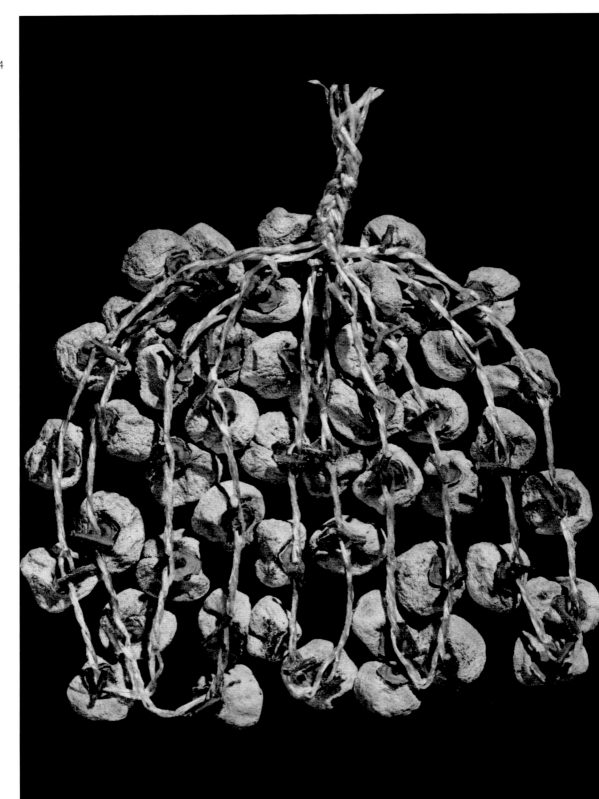

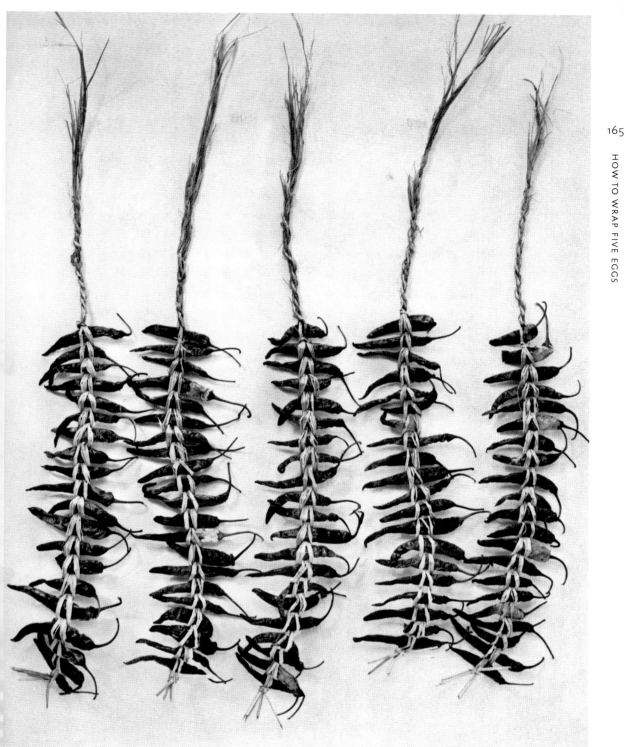

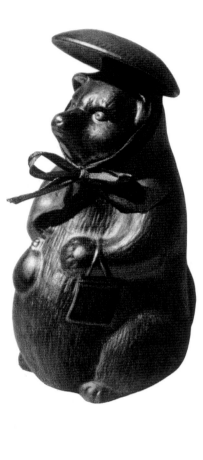

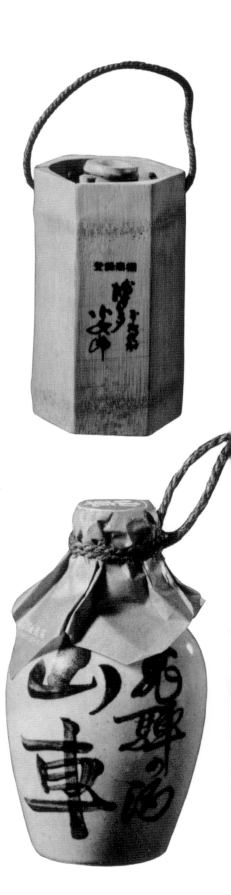

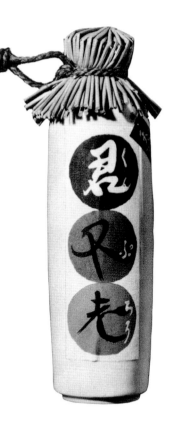

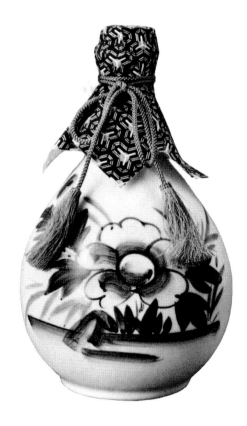

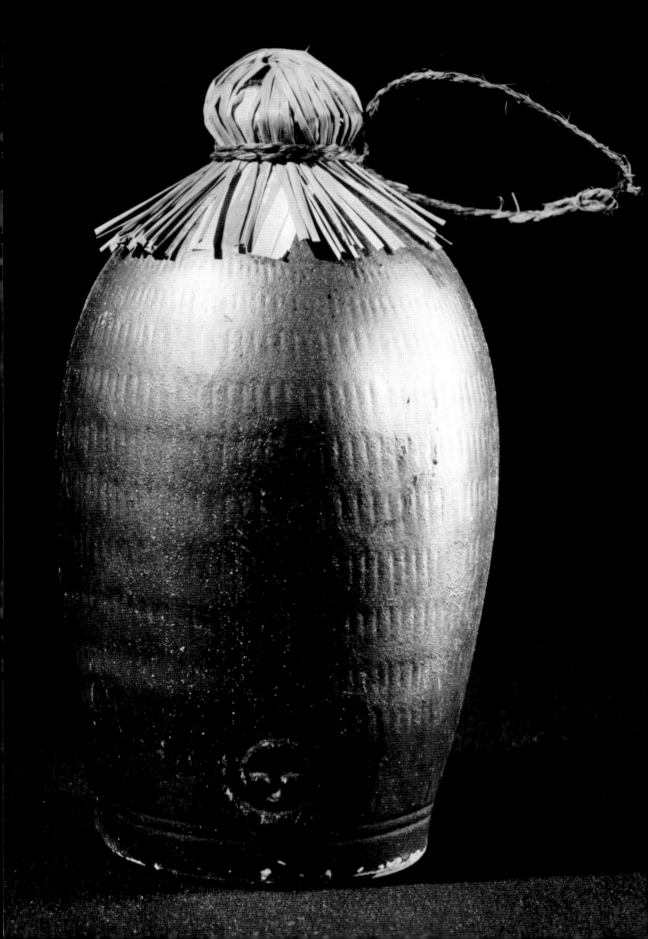

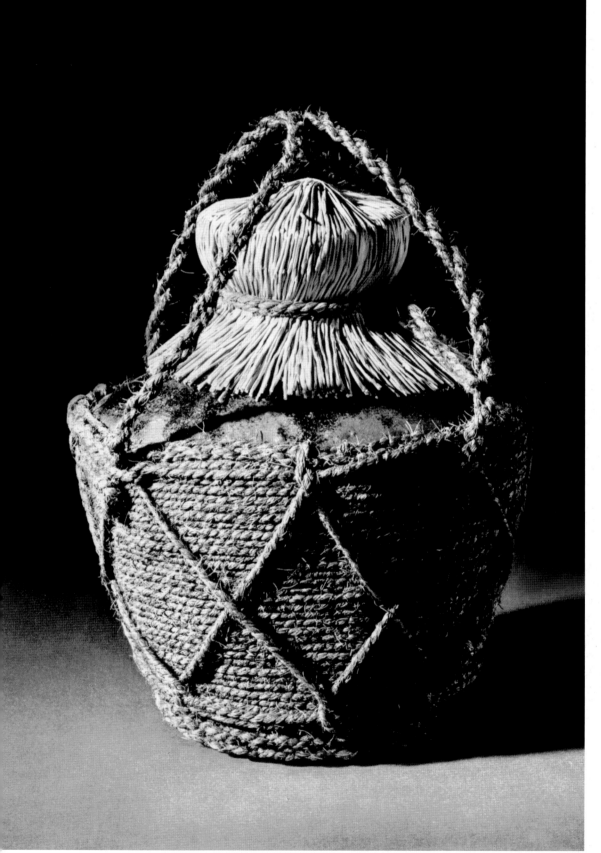

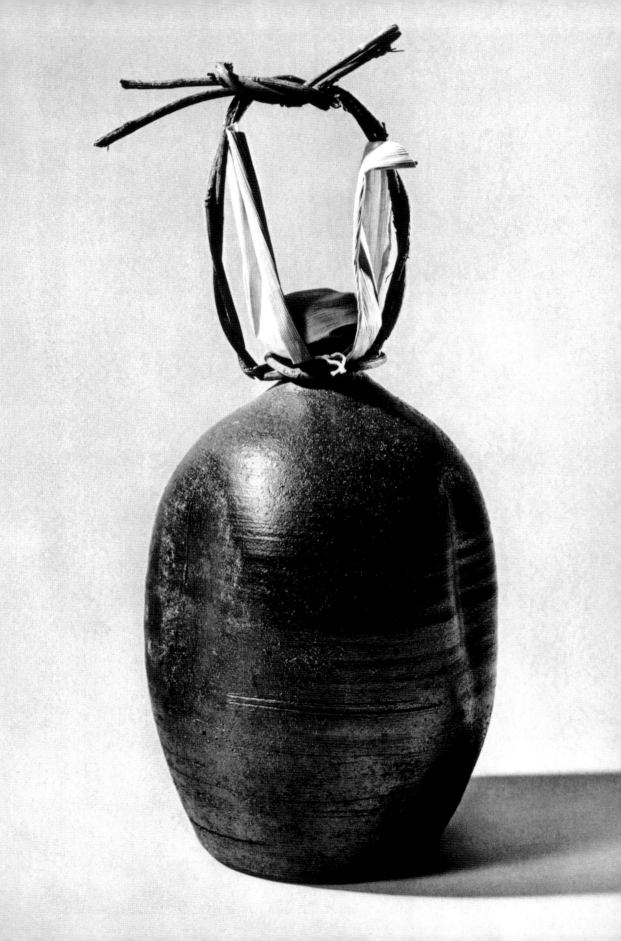

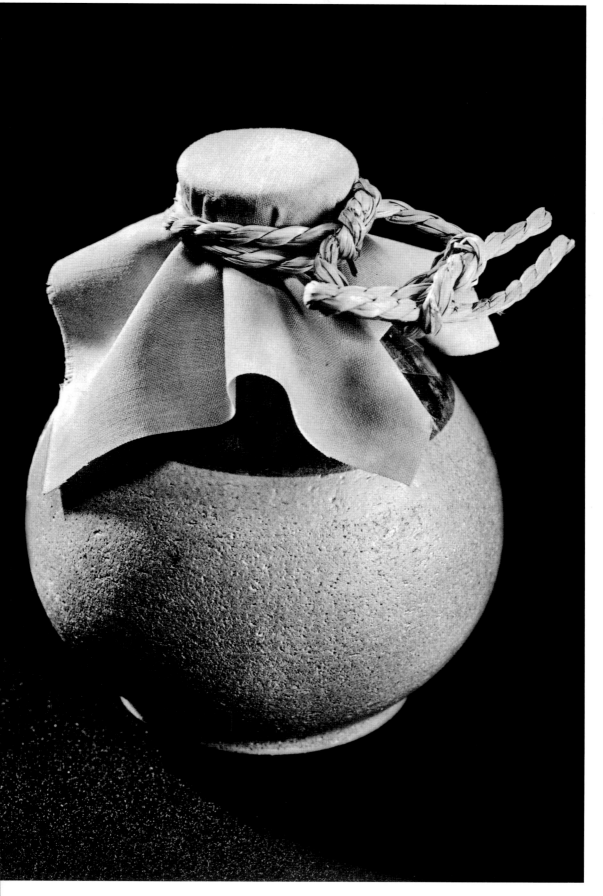

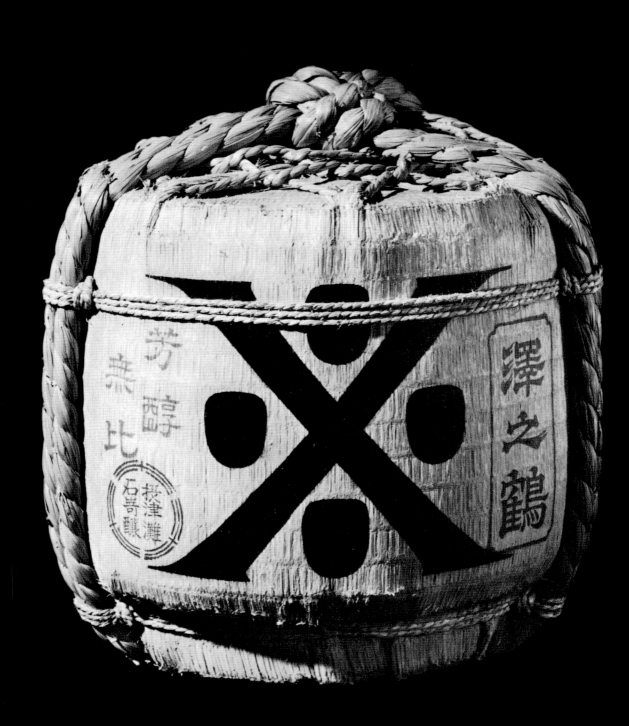

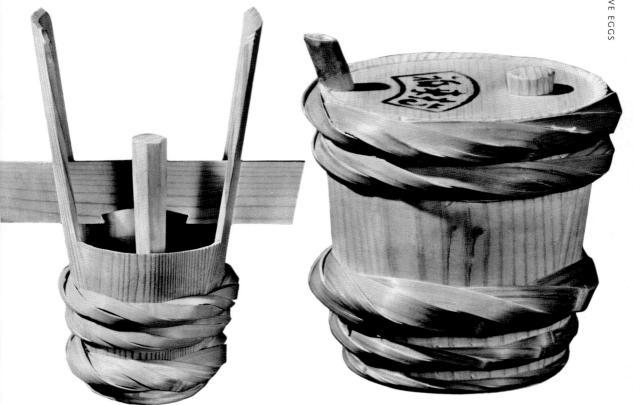

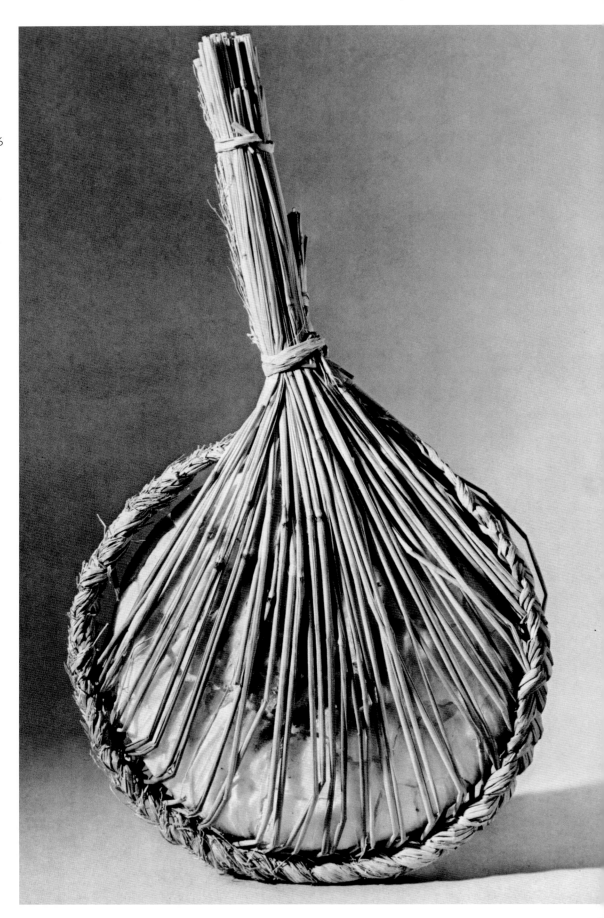

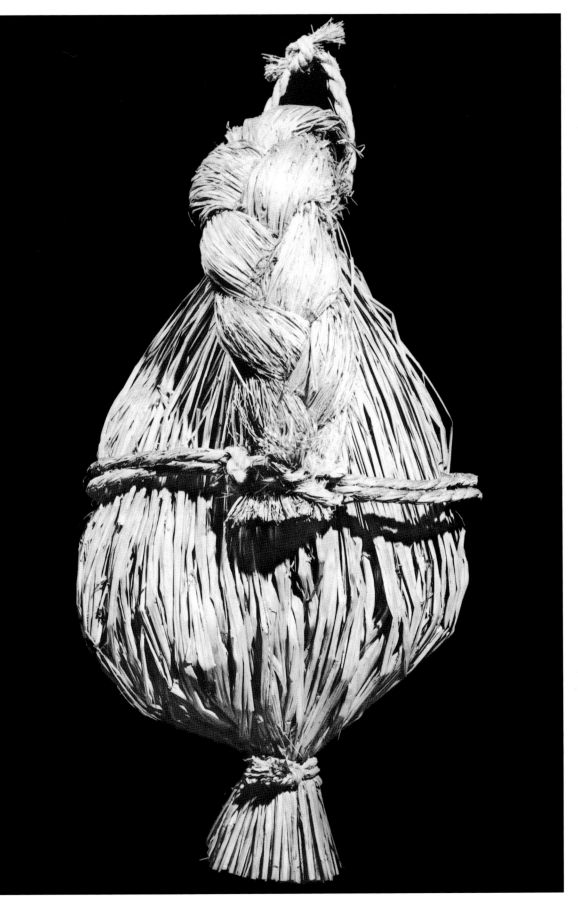

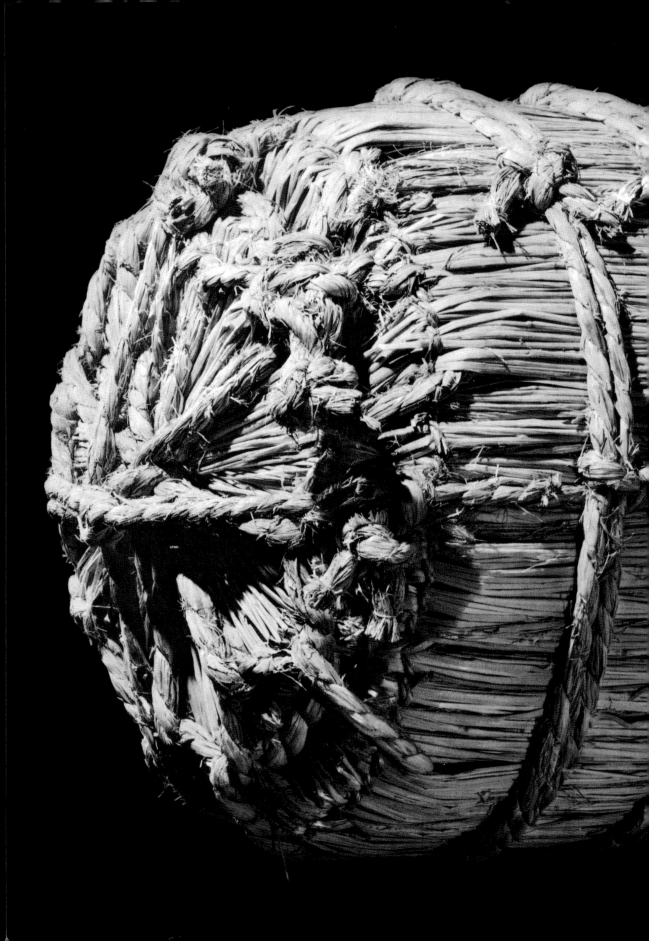

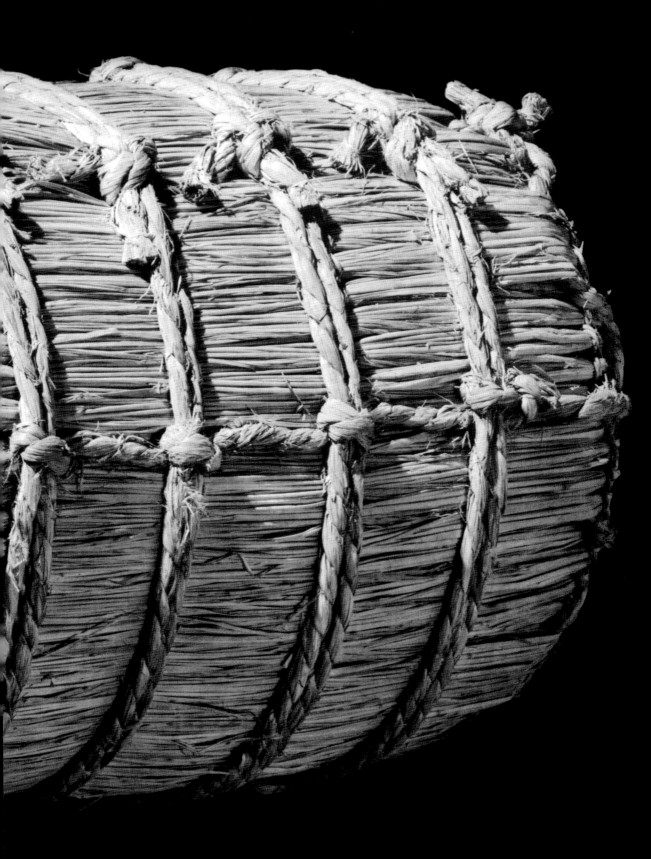

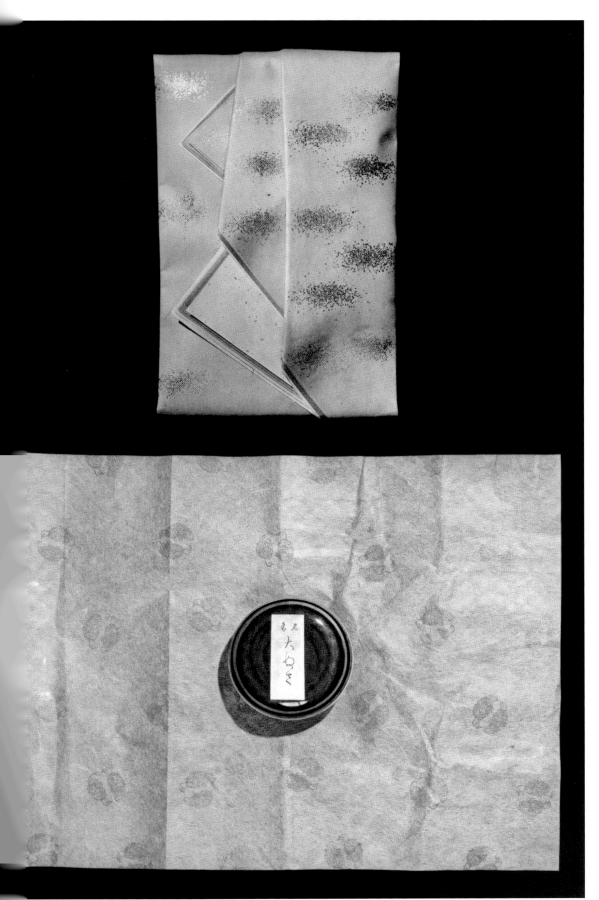

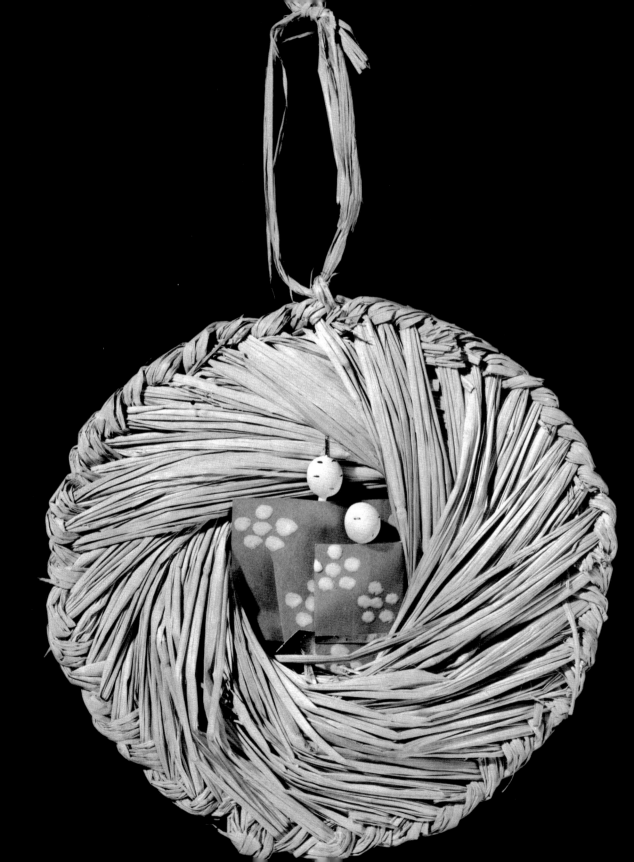

COMMENTARIES ON
THE PHOTOGRAPHS

p. 15 This ceramic confectionery container, tied with a straw cord gaily decorated with paper streamers, simulates the lion mask used in festival dances. It comes from Okayama City and is a product of the famous Bizen kilns, whose tradition dates back to ancient times. Beginning early in the seventeenth century, the feudal lords of Okayama encouraged the potters of Bizen, particularly in the creation of such ceramic figures as those of mythical lions and of Hotei, god of fortune.

p. 16, It is said that bundles of fresh ginger like this one have been sold
LEFT for more than one thousand years during festivals held at the Shiba Daijingu shrine in Tokyo. Ginger, which has been used medicinally from the earliest times, is believed to ward off evil and to invite divine influence. The red printed tag bears the name of the shrine.

pp. 16–17 Here an ingeniously cut section of bamboo serves as a container for boiled rice topped with grilled eel, a delicacy sold by the well-known Tsujitome restaurant in Kyoto. For convenience in carrying, this enticing container is wrapped in bamboo leaves and tied with a bamboo leaf cord. The entire package reflects the polish and sensitivity that are characteristic of Kyoto.

pp. 18–19 Baskets of closely woven bamboo are used to package miso (soybean paste) from the city of Aizu Wakamatsu. Ordinarily, miso is sold in containers of pottery or wood, but these packages are unusual for another reason. The soup made with miso must be strained through a bamboo sieve if it is not to be lumpy, and these baskets may be used as sieves. Here two baskets are bound together to make a package of uncommon charm.

p. 20, This forthright and colorful package carries the name of its contents:
LEFT a confection from Kagawa Prefecture intriguingly called Onizura, or Demon Face. In contrast with the elegance that we associate with the products of Kyoto, the design here has a simple charm typical of the countryside. The boldness and freedom in the choice of color, the artlessness of the calligraphy, and the simplicity of the straw cord all go together to create a delightful harmony.

p. 20, RIGHT — Miniature copies of old-style rice bales are fashioned of reed (and tied with the same material) to serve as packages for sweets from the city of Saidaiji, near Okayama City. The material is appropriate, for Okayama is famous as a source of reed for making the floor mats called tatami. The handsome label, made of dyed paper, is fastened to the package with *mizuhiki,* the cords traditionally tied around ceremonial gifts.

p. 21 — These delightfully designed ceramic bottles from Hondo on Kyushu's Amakusa Island contain camellia oil, a hairdressing accessory used in Japan since olden times. Although they are modern innovations, they follow the folk pottery tradition, and their underglaze decorations of camellia blossoms have the naive charm that one associates with folk art. To break the seal, one pulls the cord upward.

p. 22 — It is composition of design that distinguishes this box for *tsukudani* (food boiled in soy sauce) from the town of Seki, Gifu Prefecture. The box itself is nothing out of the ordinary, but the arrangement of the four squares of navy blue paper that seal it shut gives it a look of fresh vitality. The beautiful calligraphy of the label enhances the effect.

p. 23 — A handsomely made container of wood lashed with strips of bark is packed with sushi made of *ayu* (river trout) over vinegared rice. The package is almost airtight, and the contents keep for a considerable time. The shop in Shimoichi, Nara Prefecture, that specializes in this commodity reports that the container has a history of more than a thousand years.

p. 24 — Sections of fresh bamboo are split to form the sticks for these traditional candies from the old castle town of Sendai. The holder is also of bamboo, and the arrangement, suggesting sprays of flowers, displays both the charm and the great usefulness of the plant.

p. 25 — Here we see a creation of the type whose beauty is said to have astonished the celebrated sixteenth-century tea master Sen no Rikyu. Originally, confections of *mochi* (steamed and pounded rice) filled with bean jam were wrapped in *chigaya,* a species of reed, and came to be called *chimaki.* We are told that a shopkeeper named Kawabata Doki used bamboo leaves to wrap the chimaki he presented to the emperor Gokashiwabara (1464–1526) and that thereafter the use of bamboo leaves for wrapping such confections became predominant. In fact, the bamboo-wrapped chimaki seen here are known as Doki chimaki after the pioneering shopkeeper, and it is small wonder that this product of Kyoto should have an air of refinement and dignity suggestive of the imperial court. The two different flavors of the contents are indicated by

exposing either the upper sides or the undersides of the leaves. The cord used to bind the chimaki together is made of rushes, and ceremonial gift cords (mizuhiki) are attached.

p. 26 Ordinary rice straw is used imaginatively to create a most functional and beautiful container. Since a set of items in Japan is five rather than half a dozen (five teacups, five cake plates, and the like), this carrier contains just five eggs. Devised by farmers in Yamagata Prefecture in northern Japan, it is an example of packaging born of rural necessity. Interestingly enough, it seems to emphasize the freshness of the eggs.

p. 27 At the annual festival of the Shiba Daijingu, a Tokyo shrine, good luck candies are sold in tiered boxes of thin and crudely finished wood flecked with watercolor paints and tied with rice straw. The design is naive but striking, and there is a decidedly festive quality about it.

p. 28 Leaves of familiar trees have long been used to wrap food, and this practice can be observed all over Japan. Shown here are rice cakes wrapped in various leaves symbolizing the seasons. The camellia leaf (top) represents winter; the cherry leaf (middle), spring; and the oak leaf (bottom), early summer. Conveying the sense of each season in fresh form is an indigenous characteristic of the Japanese, and the desire to do so is perhaps one of the main motivations for traditional-style packaging.

p. 29 A crystal-like piece of *sasa-ame,* a candy made from sweet beans, is placed on a leaf of the bamboo known as *kumazasa.* The leaf has a layer of pectin that helps to preserve the candy and is simply folded over once to form a package. This pleasantly rustic confection is a traditional product of Niigata Prefecture.

p. 30 To make this confection from the Kiso district of Nagano Prefecture, crescent-shaped mochi filled with sweetened bean paste are wrapped in five or six leaves left intact on a single twig of magnolia, and the whole is then steamed, so that the mochi absorb the aroma of the leaves. Confections of this type are often eaten in celebration of traditional festivals at various seasons of the year.

p. 31 In this confection from the Kyoto shop Fuka, bean jam is wrapped in unbaked gluten dough and then folded inside kumazasa bamboo leaves, which give a special flavor to the contents. That even a single bamboo leaf can be turned into a beautiful package reveals the inventiveness of the tradesmen who traditionally supplied food and other commodities to the Kyoto Imperial Palace.

p. 32 This type of packaged lunch is peculiar to Kagoshima Prefecture in southern Kyushu. It consists of rice wrapped in bamboo sheath, tied with the same material, and then steamed. The effect is extremely rustic—an example, once again, of packaging born of necessity.

p. 33 The leaf-wrapped confections generally known as chimaki (see commentary for page 25) are found all over Japan, and they go by various special names—for example, *sasamaki* (bamboo-leaf rolls) and *sasadango* (bamboo-leaf dumplings)—but they are commonly tied with strong cords of sedge or rush. This method of packaging was developed principally in rural areas to preserve food and make it easily portable. Today the method is still used to create such attractive packages as the ones seen here. The top shows chimaki from Fukushima Prefecture; bottom, chimaki from Yamagata Prefecture. Both employ bamboo leaves.

p. 34 Confections for ceremonial occasions are packaged in finely crafted boxes of unpainted wood whose octagonal shape repeats that of the traditional stands used for votive offerings. Shown here at top are confections of the type offered to guests on festive occasions like weddings; at bottom, those of the type offered at funerals and memorial services for the dead. The lids (not shown here) are appropriately decorated to signify the nature of the occasion.

p. 35 Here a pottery peach tied with braided reeds serves as a container for candies from Okayama Prefecture. The inspiration for the design is the fairy tale of Momotaro, the boy born from a peach. The attached tag carries the name of the shop, the name of the original designer of the package, and the name of the pottery—the famous Bizen ware of Okayama. Appropriately enough, Okayama was the scene of the peach boy's adventures.

p. 36 The confection known as *rakugan,* resembling cakes of compressed powdered sugar, is packaged in a distinctive way by the famous Osaka shop Torindo, which also sells the products shown on pages 44; 72; and 148, middle and top right. Squares of pink and white rakugan are covered with thin boards of cryptomeria branded with the trade name under which the shop sells the confection. These are then wrapped in paper bearing the same characters and tied with a metallic cord. The effect is one of great refinement, and the package, although of traditional origin, has a decidedly modern air.

p. 37 This large pottery jar of *nure natto* (sweetened fermented soybeans) comes from Tokyo and is intended for use as a gift. Nure natto is sold in a variety of containers, some of which are suitable for later use as rice bowls. The cover, made of cryptomeria wood with a fine straight grain,

not only adds a touch of elegance but also can play the role of a coaster after the jar has been emptied, and of course the jar itself can be put into service for other purposes.

p. 38 An elegant wooden box, fashioned in the style of boxes used for gifts to the emperor some eight or nine centuries ago, is filled with a Kyoto confection called Gion Chigo Mochi. The Gion is one of Kyoto's entertainment districts, *chigo* are children dressed in ceremonial Buddhist costume for one of the city's numerous festivals, and mochi are cakes of steamed and pounded rice. The name of the confection derives from the style of the bamboo-sheath wrapping, which suggests the figure of a chigo.

p. 39 The trade name of this box of confections from the well-known Kameya Suehiro shop in Kyoto is Kyo no Yosuga (Reminders of Kyoto), but it also goes by the popular name of Yojohan (Four and a Half Mats) because the arrangement of the five interior sections copies that of the mats in a typical Japanese-style room. The contents vary according to the season of the year, and the lid is elegantly stamped with the symbol of the shop.

p. 40 Another Kyoto confection, a kind of sweetened rice paste, is simply but strikingly wrapped in a package marked with its name (*uiro*) in vigorously written characters. Simplicity could hardly be carried further, but, as seen in this ensemble of three separate packages, the effect is altogether engaging.

p. 41 This graceful box of paulownia wood contains high-quality candies from Nagoya, and its exquisite form clearly reflects the refinement of its contents. The knob on the lid, made of polished bamboo, adds a perfect decorative note. The box, of course, is meant for use even after the candy is gone, and it is decidedly an example of a package one would be reluctant to throw away.

pp. 42–43 Stage properties of the famous Bunraku puppet theater in Osaka are pictured on the wrappers of a select brand of sweet rice crackers (*sembei*) from that city. The wrappers, made of the traditional Japanese paper known in the West as rice paper, carry the name of the confection as well as brief explanations of the objects shown.

p. 44 The stunning simplicity of this package reflects the design policy of the Torindo, the shop in Yao, Osaka, where it is sold. A long bar of the bean-jam confection called *yokan* (which will be cut into small pieces when it is served) is wrapped in a sheet of foil-backed paper elegantly labeled with the name of the product and that of the shop. Although its purpose is severely functional, the wrapper effectively suggests the

high quality of the contents. Other products of this noted shop are seen on pages 36; 72; and 148, middle and top right.

p. 45 Each of these envelopes contains powdered ingredients for a cup of *shiruko,* a syrupy drink made from sweet beans—instant shiruko, to be exact, since only hot water needs to be added. The envelopes are formed of single sheets of old-style Japanese paper (rice paper, as Westerners often call it) folded in the manner of origami, the paper-folding pastime of Japanese children. The colors are achieved by traditional methods of dyeing rather than by printing. As products of Kyoto, the packages display the elegance of the Kyoto style.

p. 46 This delightful product of the Mamemasa confectionery in Kyoto features sugarcoated beans arranged in tiers in a diagonally cut card-board box pasted over with decorative printed paper. The ingenuity of the design speaks for itself, and one could hardly ask for sweets to be more temptingly packaged. The woodblock-printed label (not seen here) pictures a beautiful woman of Kyoto.

p. 47 The sembei (rice crackers) in this sturdy bag of handmade paper come from the town of Kuwana in Mie Prefecture and go by the trade name of Tagane, which derives from the name of the rice cakes offered to the Shinto gods. In fact, these sembei have a long tradition that goes back to ancient times. The silk drawstring of the bag gives it a particu-larly distinguished look.

p. 48, This package for bean jam from Ueda, a former castle town in Nagano
TOP Prefecture, is made in the form of an antique scroll. The inspiration for this clever container comes from a local celebrity of olden times: a master of the occult arts who wrote down the secrets of his trade in such a scroll. The old-style paper and the brush-written label are particularly interesting.

p. 48, A miniature copy of a steamer for *manju,* or dumplings filled with
BOTTOM sweet-bean paste, here serves as a box for the dumplings themselves. The product is from Kyoto, and the manju are placed on a mat of split bamboo in a manner suggestive of the Kyoto cuisine.

p. 49 This festive creation from Tokyo, complete with decorations of the sort that accompany ceremonial gifts, is a miniature copy of a manju steamer, like the box on 48, bottom. The cord, in the congratulatory colors of red and white, is also typical of gift packages.

pp. 50–51 The ensemble displayed on these pages represents a peak of sophis-tication in traditional Kyoto packaging. Candies called *Kyo Onna*

(Women of Kyoto) are gracefully boxed in a manner suggestive of the beauty and elegance of the ladies for whom they are named. The characters for "Kyo Onna" in the center of the lid are reproduced from the writing of Yachiyo Inoue, a woman famous in the Kyoto world of classical dancing. The cord is of woven silk. As a climactic touch, the box is wrapped in a replica of an antique map of Kyoto.

p. 52 Here the opened paper wrapper for a Kyoto confection called Evening Moon takes the place of a dish for serving it. To add to the rather lyrical effect created by the name and the appearance of the confection, the wrapper is delicately decorated both inside and out and bound with a strip of paper inscribed with a poem. This is the very essence of the Kyoto style of packaging.

p. 53 The Kyoto shop Kameya Suehiro wraps the confection called Kyo no Tsuchi (Earth of Kyoto) in a plain white sheet of handmade Japanese paper inscribed with the name of the product in masterly calligraphy. There is nothing dramatic about the package, but it is decidedly elegant in its simplicity.

pp. 54–55 Two methods of packaging the Kyoto confection called *masakari mame* (a variety of candy-coated beans) are seen here. In the first, the container is made of the same substance as the candy inside and consequently can be eaten as well. In the second, the box is a replica of an old-style rice measure. The confection itself is said to have been invented by a medieval Buddhist saint. It is one of the most famous of Kyoto sweets.

p. 56 The paperlike sheath of the young bamboo shoot is here used as the wrapping for a popular type of sweet rice dumpling called *dango*, in this case the specialty of a shop in the old castle town of Toyohashi, near Nagoya. Bamboo sheath is also used to tie the package. Two squares of colored paper are added for decoration, the topmost one carrying a bold design in the style of an early woodblock print.

p. 57 This delightful Tokyo conceit is typical of inventive packaging for summer. Confections in the shape of the summertime fish called ayu (a species of freshwater trout) are arranged in a container fashioned of reed matting to resemble a fisherman's creel. Since reeds, like the delicious and highly favored ayu, are symbolic of summer, the whole effect speaks of that season.

p. 58 Two Tokyo styles of packaging the beloved bean jam called yokan are seen here. Both make use of the reliable bamboo sheath. The boxed yokan (two kinds) on the left is from Toraya, one of the oldest of Tokyo's confectioneries, and is intended for use as a gift. The package on the right comes from the Asakusa district, site of a famous temple,

and the label appropriately pictures one of the two statues of guardian gods that stand at the temple gate.

p. 59 *Monaka* (rice pastries filled with bean jam) from a Tokyo confectionery are festively packed in a round container of bamboo sheath. Since the package is meant for use as a gift, it carries the proper accessories, including the cords called mizuhiki, which are here arranged to repeat the circular design of the box. Hemp twine and dyed paper complete the ensemble.

p. 60 Reed matting in natural color, dyed paper of traditional make, and woven cord are used with vivid effect to package a special brand of yokan (sweet bean jam) from Osaka. The varieties are distinguished by the colors and the labels. For sheer freshness and vibrancy, these packages would be hard to excel.

p. 61 These Kyoto pastries are wrapped and tied in imitation of the packs carried by old-time travelers in Japan. Such packs were slung over the shoulder, one dangling in front and the other in back. The uncommonly long brand name of the pastries, Gojusan-tsugi Shin Jippensha, is an allusion to a famous comic novel of adventures on the old highway between Edo (now Tokyo) and Kyoto, and the packages are thus appropriately symbolic. Old-style Japanese paper is used for the wrappers and reed leaves for the cord. The bamboo-sheath container is held together with thin dried vines.

p. 62 An Osaka confection called Yagura Okoshi is packaged in a wooden box decorated with boldly written characters (the name of the contents) and a design suggesting a feudal lord's encampment. A sheet of dyed paper with designs of family crests covers the top. The style of the box itself, the vigor of the decorations, and the way the straw rope is tied give an impression of energy that is typical of the mercantile city of Osaka.

p. 63 Cakes from Kyoto, intriguingly named Fountain of Youth, are sold in a multiple package suggestive of three favorite Japanese poetic and artistic themes: snow, the moon, and flowers. The changing seasons are also reflected here. At the bottom are snow-laden pine boughs; in the center, cherry blossoms over a stream; at the top, the moon, in which the Japanese see, instead of a man's face, a rabbit pounding rice.

pp. 64–65 The cargo of this miniature riverboat is citron-flavored cakes from Sakata in Yamagata Prefecture. The paulownia wood of which the container is made has been scorched and washed to bring out the beauty of the grain. This is another example of a container that can be put to

later use—as a holder, perhaps, for small items in the kitchen or a tray for pens and pencils.

pp. 66–67 Summertime candies, made in Kyoto and meant to be kept cold, are packed in baskets woven of bamboo strips, and containers and all can be kept in the refrigerator. Bamboo baskets are of course quite common as packaging, but these are distinguished by particularly elegant lids.

p. 68 In old Japan the "seven herbs of spring" were eaten to insure good health and good fortune during the first half of the year (which then began with spring). There were also the "seven herbs of autumn" as a similar guarantee for the rest of the year. Today this custom no longer exists, but the Tokyo park known as Hyakka-en preserves a memento of it by selling bamboo flower baskets like this one planted with the seven springtime herbs. The long, graceful handle of bamboo strips is particularly attractive.

p. 69 Three confectionery baskets of loosely woven split bamboo display a charming sensitivity of shape and line. The ones at the top and bottom right are from the city of Fukui, on the Sea of Japan not very far from Kyoto; the other, from Hamamatsu, Shizuoka Prefecture. Similar packaging with split bamboo can be seen almost everywhere in Japan.

p. 70 These Kyoto candies, temptingly sprinkled with sesame seed, are made in imitation of slices of roasted sweet potatoes, a cheap and common wintertime food in Japan. There is a certain sophistication in elevating the status of a lowly food in this way, and the result is undeniably charming. Sprigs of cedar are added as decoration. The beautifully crafted basket of split bamboo is meant for later use, as is the cloth napkin (not seen here) that serves as a cover. The accompanying message from the shop describes the confection and speaks of the high reputation it has attained.

p. 71 The theme of this charming fantasy from Nagoya is tea. Tea-flavored candies called *cha-ame* are packed in a bamboo basket whose bamboo-sheath cover is tied on with twine and adorned with artificial tea blossoms. Although the allusion is not specific, the basket suggests the gathering of tea leaves, and the cover, by a slight stretch of the imagination, may be seen as a copy of the hats worn by tea pickers.

p. 72 Another product of the Torindo (pages 36; 44; and 148, middle and top right) is a pounded rice cake flavored with citron: a delicacy that is said to have originated in the fifteenth century as one of the refreshments served during the tea ceremony. The Torindo packages the cakes

in wrappings of soft, thin Japanese paper and sells them in bamboo baskets of rustic style—all in keeping with tea ceremony traditions.

p. 73,
TOP

This small bamboo basket from the Tsukiji district of Tokyo serves as a container for any of the various seasonal confections sold during the year. It copies the *yama kago,* or mountain basket, originally used by peasants for gathering fruit and nuts in autumn. The bamboo rake enhances the rustic quality and at the same time adds a humorous touch.

p. 73,
BOTTOM

Here a miniature basket of woven bamboo with a bamboo-sheath cover serves to hold enticing candies called Morning-Glories. In this creation, intended for sale during the summer, the Kyoto shop Kamiya Ryoei, which dates back to 1832, displays both its fine sense of design and its vigorous adherence to traditional modes of packaging. The characters on the label are written by hand.

p. 74

This container is a miniature version of the cages in which the cormorant fishermen of the Nagara River carry their birds. It comes from Gifu City, through which the river flows, and is designed to hold packages of the bean jam called yokan. The material is bamboo, and the twine is made of natural plant fibers. One can readily see why traditional packaging like this is vanishing in the present age of synthetics and speed.

p. 75

The seasonal element is reflected in these containers for summer yokan, a kind of jam made from sweet beans. Sections of fresh bamboo are filled with the confection and capped with a wrapping of leaves from the *sasa* (dwarf bamboo) plant. When the bottom of the tube is pushed, the yokan comes gliding out. The refreshing green of the tube and the leaves, along with the light and airy look of the basket (also of bamboo), is immediately suggestive of summer. A white card attached to the lid of the basket bears the name of the product and that of the shop in Kyoto where it is sold.

p. 76

The brand name of the yokan in this captivating package is Hoshi Matsuri, or Star Festival. The yokan is stuffed into sections of bamboo stem, and those, in turn, are individually wrapped in bamboo sheath and tied with bamboo-sheath cord. The handle is also made of bamboo. This is indeed a remarkable work of art in which every element of the package is made of one natural material.

p. 77

This bamboo basket for candies from the northern city of Aizu Wakamatsu is a copy of the baskets in which farmers traditionally carried the whetstones to sharpen their sickles. The cover consists of a square of metallic paper over one of plain white, and the hemp cord is tied in a special way to make a loop for carrying the package.

p. 78 Two Kyoto confections are packaged with almost classic simplicity
in sections of bamboo. The container on the left copies the water
buckets used at Kyoto's hundreds of temples. The one on the right is
distinguished by the interesting manner in which it has been cut at the
top. Both are designed for later use as vases. The dyed paper labels add
a touch of gaiety to the otherwise severe forms.

p. 79, A shop in Otsu, Shiga Prefecture, called the Toshojuan packages the
LEFT sweets known as Tamatesuki in a section of bamboo stem wrapped
with paper from Omi Kiryu, in the same prefecture. The paper,
inscribed with a poem from the ancient anthology *Man'yoshu,* is the
most distinguished part of the package, for it is the product of a tradi-
tional papermaking process that has been designated by the Japanese
government as an intangible cultural property. The attractiveness of
the package is further enhanced by the addition of strips of colored
paper, a beautifully written label, and cords of the type used for gifts.

p. 79, Like the bamboo basket of candies shown on page 64, bottom, this
RIGHT candy-filled container of green bamboo is a product of the Kyoto shop
Kameya Ryoei. The container itself, the bamboo-sheath cover, and the
simple label (which reads "Kotoshi-dake," or "This Year's Bamboo")
suggest the age and dignity of this long-established shop.

p. 80 The outer wrapper of this Kyoto candy is bright red paper dyed by old-
time techniques. The writing is also dyed rather than printed. In serving
the candy, one peels back the interior bamboo-sheath wrapper and
slices off as many pieces as are wanted.

p. 81 Here a section of bamboo has been split in half to form a splendidly
functional container for persimmon-flavored yokan. A bamboo knife
is supplied for cutting and serving the confection. This packaging idea
comes from the town of Ogaki, Gifu Prefecture, where it is said to
have originated almost a century ago.

p. 82 This tropical-looking package for rice crackers is woven of strips of
bamboo sheath—an interesting variation in the use of this ubiquitous
material. It comes from the island of Kyushu—from the vicinity of the
volcano Asozan in Kumamoto Prefecture.

p. 83 Straw, bamboo, and wood are used here to make a candy box in
imitation of the famous Shirakawa houses of Gifu Prefecture. In these
capacious farmhouses, built during the feudal age, the first floor served
as the family living quarters and the upper floors for the cultivation of
silkworms. The package contains candied beans and is sold by a shop in
Osaka. It is also exported to the United States.

p. 84 Oilpaper has been used for centuries in Japan as a moisture-proof material. Here it is stretched over loosely woven bamboo to make confectionery boxes of rather homely but nonetheless pleasing appearance—the one on the top from Sendai, the other from Niigata City. Both boxes, in spite of their unpretentious look, are used to package local confections of high quality.

p. 85, TOP Although bamboo sheath is frequently used as material for boxes and other containers, it is rare to find a box made of bamboo leaves. This engaging creation from Takada City in Niigata Prefecture is made of sasa (dwarf bamboo) leaves bound over a framework of split bamboo. The natural fiber twine enhances the delightfully rustic appearance, and the triangular label is a distinctive touch. The contents are filled rice pastries called Okesa Monaka.

p. 85, BOTTOM Bamboo sheath, bamboo slats, bamboo strips, dried vines, and natural fiber twine are attractively brought together in this box for sweets from Niigata City. There is no special attempt at refinement—in fact, the impression is one of honest sturdiness rather than conscious artistry—but there is a definite charm in the combination of natural materials, textures, and colors.

p. 86 Reeds are commonly used for packaging in Japan, and here reed matting forms the containers for two paste-like confections from Nagoya. To each package is attached a sturdy sliver of bamboo (appropriately wrapped in bamboo sheath) for use in cutting and eating the contents. Labels of brightly dyed paper add a touch of liveliness against the neutral tones of the reeds.

p. 87 The sheath of the bamboo shoot is used in a great variety of ways for wrapping and packaging. In this example, dried persimmons from Matsuyama, on the island of Shikoku, come in a fan-shaped package made of bamboo sheath held together with thin dried vines. The lid is itself a fan, the bamboo sheath having been sewn over a framework of split bamboo. Somehow this rather countrified container seems exactly right for the dried fruit inside.

p. 88, TOP Here the Kyoto confection called masakari mame (see commentary for pages 54–55) is offered for sale in a miniature bamboo basket that simulates those used for winnowing rice, raking leaves, and the like. This charming creation is small enough to hold in the palm of one's hand. The tiny basket and the tempting green of its contents suggest the fallen leaves and the moss-carpeted ground at Kyoto's famous "Moss Temple," the Saiho-ji.

p. 88,
BOTTOM

The Kyoto candies called *goshiki mame* (sugarcoated beans in five colors) are usually packaged in replicas of the old fashioned measure once used for rice and other commodities. The version of this simple box seen here is wrapped in gaily dyed paper and tied with gift package cords of red and white.

p. 89

To make this candy box replica of an old-style wicker trunk, paper is pasted over a base of woven bamboo and then painted. This is still another example of packaging inspired by humble objects of everyday use. It comes from the northern city of Sendai.

p. 90,
LEFT

For the Doll Festival of March 3, a traditional celebration in honor of young girls, a Tokyo confectioner packages special candies in a bag of crinkled Japanese-style paper decorated with pictures of dolls in antique costume. The bag is furnished with a double drawstring of brightly dyed silk.

p. 90,
RIGHT

Another candy bag, this one from Toyohashi, near Nagoya, is made of crimson paper embellished in gold with a traditional motif of Chinese origin. It is tied with a simple paper cord. The effect is showy, but the design has style.

p. 91

Confections from an old and well-known shop in Tokyo come in a bag of striking design that takes its inspiration from the Bunraku puppet theater of Osaka. Against a background pattern suggesting a sliding paper-and-wood door, the head of a Bunraku puppet stands out boldly, and the name of the product appears in characters of theater-poster style. The shop, which was founded in 1890, has the motto "Modern taste derived from a long tradition."

pp. 92–93

These candy bags from Shizuoka City represent the girls who pick the tea for which the region is famous. Sheer charm in packaging could hardly go further. The dyed paper copies traditional patterns for kimono fabrics, the packages themselves imitate the shape of the kimono (even to the sleeves), and the hats, of course, are miniatures of those worn by the tea pickers. It seems only logical that the candy in the packages should be called Cha Otome: Girls Who Pick Tea.

p. 94

A round cardboard box, delicately decorated with a picture of lovers in ancient costume, contains the Nagoya candies called Futari Shizuka: pink and white bonbons wrapped in pairs in thin rice paper. The paired bonbons, of course, carry out the theme of the picture on the cover, and the name of the candies may be translated as "two persons quietly together."

p. 95 Paper-wrapped candies, with an artificial blossom as a tasteful decorative note, are packed in a foil-covered box shaped like a folded fan. Boxes of candy like this one are not for sale on the market but are made to order for such occasions as Japanese dance recitals, when each guest receives one as a gift. The fan, of course, is an important accessory of the classical Japanese dance, and this fan-shaped box, from Tokyo, is reminiscent of bygone days when that city was still known as Edo.

p. 96, TOP A folded paper package from Osaka is filled with candies for the Doll Festival. It is designed to resemble an elevated serving tray used on felicitous occasions and is thus in keeping with the mood of the day. The dyed paper copies a traditional textile pattern.

p. 96, BOTTOM The confection called Chitose (A Thousand Years) is a product of the Kyoto shop Kameya Suehiro, whose elegant style of packaging has already been seen on page 53. For wrapping Chitose, the shop uses a delicately dyed handmade paper decorated with pine branches in pleasing tones of brown.

p. 97 This boldly designed package from Kagawa Prefecture contains a confection called Taiko (Drum), a product of the same shop that sells the Onizura on page 20, left. Not only the pattern and the colors but also the strongly written characters of the name Taiko reflect the vigorous character of the people in the region where the product originates.

p. 98 A box of plain wood, almost resplendently decorated with gift-package accessories, holds a large (15 square inches) sponge cake called *kasutera*. The two sixteenth-century Portuguese pictured on the label are symbolic, for it was the early Portuguese visitors to Japan who introduced kasutera (the name comes from their word for it) and taught the Japanese how to make it. It is still a favorite delicacy and is known throughout the country. The package seen here is a Tokyo product.

p. 99 The Seven-Five-Three Festival, a celebration in honor of girls aged seven and three and boys aged five, is the occasion for buying packages of *chitose ame* (thousand-year candies) decorated with such emblems of long life as the tortoise and the crane. The candies serve as gifts for the youngsters to present to their friends on this festive day. Chitose ame packages like those seen here are found everywhere in Japan.

p. 100 Printing in old Japan was done with hand-carved wooden type. The process was laborious, but the results were often strikingly attractive.

A confectionery in Kyoto wraps its sweets in reproductions of old-style printing, skillfully using the decorative effect of the hand-carved characters and adding a note of emphasis by tying the package with colored paper cord.

p. 101 In an effort to improve its image by introducing art into commerce, the famous shop Nakamuraya in Tokyo commissioned the distinguished woodblock print artist Shiko Munakata to design its wrapping paper. Shown here, with their typical Munakata designs, are three different wrappings for yokan. In each case the printed sheet of paper, instead of covering the entire container, is tied over its top.

p. 102 The city of Kurume in northern Kyushu is famous for a type of cotton cloth called *kurume kasuri*. A confectionery in Kurume uses the cloth as an outer wrapper for its packages of bean jam, cleverly taking advantage of the attractiveness of one local product to enhance that of another.

p. 103 Japanese-style paper is used throughout to make this package for a quality brand of sweets from Kyoto. Even the cord is of paper. The package copies the wrapper or case of an old-style Japanese book. The soft-textured paper, the subdued colors in which it is dyed, and the formal elegance of the calligraphy are all marks of the Kyoto style.

p. 104 A paper candy box from Hamamatsu, Shizuoka Prefecture, is shaped like a *tsuzumi,* the age-old hand drum still used in the traditional theater and the classical dance. The candy itself is a Hamamatsu specialty, and local products of this sort are often bought by travelers as souvenirs.

p. 105 Yokan (bean jam) usually comes in such readily disposable containers as bamboo sheath and foil-backed paper. Here, however, is a yokan container that one would be less likely to throw away. Shaped like a squat sake bottle, it splits in the middle to form two small dishes that can be used for condiments and the like. It comes from the city of Toki, Gifu Prefecture.

p. 106 Rice pastries filled with sweet bean jam and shaped like old-time gold coins are individually packaged in wooden boxes by a confectionery in Nagoya. The brand name of these delicacies (which, incidentally, come in different flavors of jam) is the same as that of the coin: Senryo. It appears on the pastries themselves and on the lid of the box, where it is branded with a hot iron. The coins, incidentally, were kept in individual boxes similar to the one used here.

p. 107 This interesting combination of the circle and the square is the design idea of a shop in Kyoto. The studied artistry of the label contrasts nicely with the plainness of the box itself and the natural fiber twine used to tie it. The package contains select confections intended to suggest a feeling of coolness in the heat of summer.

p. 108 There is an artless charm about this candy box from Tokushima City. The combination of colors and textures is remarkably pleasing, and the design is plain but attractive. The materials are simple: thin sheets of wood, crinkled paper dyed in an appealing shade of blue, and cherry bark for the knob on the lid. The name of the product is branded on the side with a hot iron.

p. 109,
LEFT The Suzuya confectionery in Tokyo packages its *ama natto* (candied beans) in beautifully crafted small round containers of unpainted wood. Silk cords in the congratulatory colors of red and white are attached at the sides to form a handle. The effect is altogether charming and, at the same time, suggestive of old-time Tokyo when it was still known as Edo.

p. 109,
RIGHT The delightfully decorated miniature wooden bucket shown here contains white sake, the traditional drink for the Doll Festival (or Girls' Festival) on March 3. Since peach blossoms are symbolic of the day, an artificial one is attached to the handle of the bucket. This engaging creation, clearly of a design that attracts young girls, is a product of the famous Tokyo shop Akebono.

p. 110,
LEFT The rustic look of this package immediately suggests the freshness and wholesomeness of products from the country. Plain rice straw, hemp twine, and a strip of cloth are used to create the rural effect, and the style of the label is also countrified. The confection inside is a local specialty from Tsuruoka in the northern prefecture of Yamagata.

p. 110,
RIGHT In this rustic-looking package from Hiroshima City, dried persimmons are wrapped in rice straw and strikingly labeled with a band of red paper that creates a rather dramatic effect. Products like this one are often used by travelers as souvenir gifts for friends and relatives back home. There is an irresistibly warmhearted quality about this simple but effective package.

p. 111 Sugarcoated walnuts from Ishikawa Prefecture are packed in small straw baskets and sold under the trade name of Chitose Kurumi, or Thousand-Year Walnuts. Both the confection and the container are traditional products of this prefecture. The basket copies the *tego* (hand baskets) used by farmers to carry unhulled rice and vegetables.

p. 112 *Kurumi mochi* are walnut-flavored rice dumplings preserved in syrup. The ones shown here, temptingly offered for sale in an unusually large ceramic pot, are a product of the Sakai district of Osaka. The lid of the pot is inscribed with the character that means both "congratulations" and "long life."

p. 113 This pleasingly crafted wooden box contains sushi wrapped in magnolia leaves. It is a product of the town of Ena in Gifu Prefecture, but it is not unique, for similar products can be found in rural districts all over Japan. Here again, natural material is used for packaging, and in this case the main vein of the leaf is used as a string to tie the package. The wooden box is a copy of the molds used in making *oshi-zushi* (pressed sushi).

p. 114 The Osaka restaurant Sushiman invented this rather fantastic looking container for one of its specialties: *suzume-zushi,* or pressed boiled rice and *kodai* (small sea bream). The lid is firmly lashed down with lengths of vine wound around sections of split bamboo. The buff tone of the wood, the bright green of the bamboo, and the greenish brown of the vine lashings combine to give the package an inviting look and a decided air of freshness.

p. 115 Like the tub on page 116, this attractive box of mottled bamboo is a container for sushi and a product of Osaka. The slats forming the lid are bound together with braided cord to suggest a mat, and this theme is repeated by the sushi inside, which comes in rolls, each wrapped in reed matting.

p. 116 Plain wood, newly cut bamboo, and vine are vigorously brought together in this tub for pressed sushi (fish over boiled rice), a favorite Osaka dish. The staves are bound together with strips of bamboo, while the intricate lashing of vine holds the three sections of split bamboo in place and forces the cover down. Bamboo leaves trimmed into various shapes are a traditional decoration for containers of sushi, and here they decidedly add to the effect of freshness created by the other materials of the package.

p. 117 Salmon-trout sushi from Toyama City is packaged in much the same way as the Osaka product seen on page 116. Again the lid of the container is held down by pieces of split bamboo firmly lashed with vine. An arrangement of trimmed bamboo leaves covers the contents.

p. 118 There is practically no artifice at all in these containers for preserved Japanese peppers from Nagano, a city in northern Japan. Sections of birch logs form both box and lid, which are held together with a single

brass nail. The effect is stunningly simple and at the same time symbolic, since the birch grows abundantly in the Nagano area.

p. 119 Here a primitive-looking but cleverly fashioned box of cryptomeria bark holds preserved Japanese peppers from the resort town of Kinosaki in the mountains near Kobe. Of particular interest is the skillful way in which triangular pieces of the bark have been used to form the sides of the box. The design is unaffected and appealing.

p. 120 The refined Kyoto style is once again evident in this box for broiled eel, a favorite summer dish in Japan. The shape is that of a riverboat, and the attached chopsticks suggest the oars. Four brass nails on each side are enough to hold the box together.

p.121 There is an engaging honesty about this container from the port city of Wakasa Obama, Fukui Prefecture. It is used to package salted kodai, a species of small sea bream caught in the Sea of Japan. Staves of unfinished wood form the sides, which are sturdily bound with strips of split bamboo. The dyed paper cover and the rather elaborately tied straw rope enhance the vigorous feeling of the package.

p. 122 In olden times the fermented soybean paste called miso was usually marketed in pottery jars, but here the container, a product of Sendai, is a basket of split bamboo. The designer of this exceptionally appealing package is Tadao Ujihara, and he is obviously to be commended for his skillful use of traditional materials to create a modern innovation. The pattern of the weaving and the design of the lid are only two of its attractions. Even more interesting, perhaps, is the accent provided by the handle, which is made of paper cords glued together into a single strip, replacing the old-style handle of bent bamboo.

p. 123 There is a decided flavor of old Edo (the Tokyo of feudal days) in this miso container from a Tokyo shop. The clean and simple treatment of cryptomeria wood and split bamboo is effectively set off by the handsomely tied straw rope and the square of dyed paper on top. The label seems to emphasize the forthrightness of the whole package.

pp. 124–125 Once more, as in the preceding two plates, these are containers for miso. The wooden box on page 124, a product of Osaka, is lacquered in black on the outside and in bright red on the inside. The binding of split bamboo, in natural color, gives it a sturdy look. On page 125, top, the package is actually the serrated ceramic mortar in which miso is creamed, and it is conveniently provided with a wooden pestle for this purpose. The bead serves for drawing the cord tight. This stylish package comes from Fukui City. The box of cryptomeria bark on page 125, bot-

tom, contains miso produced at the Todai-ji, the ancient and celebrated temple at Nara, for one of its annual festivals. Primitively made and simply labeled, it somehow suggests that it has a long history behind it.

p. 126 Strictly speaking, this interesting container of bamboo and vine is not a package. It is a replica of the old-fashioned salt basket that used to hang in practically every Japanese kitchen. Today it is sold as a folkcraft product designed more for decoration than for actual use. It comes from Kagoshima Prefecture in southern Kyushu.

p. 127 There is a summertime air about this bamboo-and-vine basket for sushi from a shop in Tokyo. The sushi, composed of portions of vinegared rice topped with slices of fish and other seafood, are wrapped in bamboo leaves, and the fresh green of the wrappings, showing through the loosely woven bamboo, adds to the attractiveness of the package. The lid, with its bit of vine as a pull, is especially pleasing.

p. 128 In this interesting arrangement, two shallow and loosely woven bamboo baskets are bound together with rice-straw rope to form a container for dried fish. The two ends of the rope are tied in a loop to form a handle. The design here is deliberate rather than casual, for the looseness of the weaving allows the air to pass through, and the package is a most convenient one for carrying. It is a product of the Inland Sea area.

p. 129, The shape of this basket from Yamanashi Prefecture represents an ac-
LEFT commodation to the foodstuff it is designed to contain: long, slender roots of mountain burdock that have been pickled whole in soybean paste. The woven bamboo strips make an attractive pattern, but it is the treatment of the handle that is particularly interesting.

p. 129, These small and simple but delightfully designed trays of split bamboo
RIGHT are used in the city of Aizu Wakamatsu to market pickled "mountain vegetables" such as edible ferns and wild asparagus. A paper wrapping completes the package. The trays are intended for later use as holders for the hot towels offered to guests in Japan. Such trays are found throughout the country in many styles.

p. 130, From the rural town of Takachiho, Miyazaki Prefecture, comes this
TOP delightful bamboo basket for packaging preserved Japanese peppers. Its main charm is its graceful shape, but the texture and weave of the bamboo are hardly less attractive. The straw rope reinforces the structure of the basket.

p. 131, The idea of packaging boiled noodles in a bamboo basket may seem
TOP quaint at first thought, but here one can see how effectively it can be

done by lining the basket. Noodles are eaten cold as a summertime dish in Japan, and there is a refreshing suggestion of coolness about this basket. Two flavors of noodles are offered, and the product is a seasonal specialty of the shop in Kyoto that sells it.

pp. 130–131 This captivating lunch container from the Museitei restaurant in Gifu Prefecture consists of a shallow basket of woven bamboo and a lid of woven cypress that copies the pattern of traditional woven hats. The two parts are held together by hemp cords drawn up through a sliding bead. The package is an example of rusticity and luxury combined, for the cypress lid makes it more expensive than the lunch itself, and it is now no longer being made.

pp. 132–133, The model for this package from Fukuyama, Hiroshima Prefecture, is
TOP the folding hat of sedge formerly worn by farmers and travelers. The package contains a whole baked *tai* (sea bream), a fish much relished in Japan, and it is said that the feudal lords of olden days often included tai in wrappings like this among their gifts to the shogun when they returned to the capital from their fiefs.

pp. 132–133, Long sheaths of rice straw like this one, firmly but gracefully tied with
BOTTOM rice-straw cord, contain yams from Gumma Prefecture. Their rural look, enhanced by the quaintness of their labels, gives them a decided appeal, and it is small wonder that city dwellers find it irresistible to take them home as souvenirs.

p. 134, Here a whole dried and salted fish (a yellowtail, to be exact) has been
LEFT wrapped in a sheath of straw and wound with a continuous length of straw rope. The effect is attractively rustic, and the tightly wound rope makes a pleasing pattern. When the fish is to be eaten, it is necessary only to unwind the rope partway, slice off as much as needed, and then close the package by rewinding. This rope-wound yellowtail— *makiburi*, as the Japanese call it—is a well-known product of the city of Kanazawa, Ishikawa Prefecture, on the Sea of Japan.

pp. 134–135 *Homeishu,* Japan's oldest medicinal tonic, is a kind of liqueur made from a number of different Japanese and Chinese herb essences. The famous homeishu produced in Fukuyama, Hiroshima Prefecture, is sold in bottles of Bizen ware wrapped in straw matting. Two styles of wrapping are shown here. In the simpler one (page 134, right) no box is used, and the matting is wrapped directly around the bottle. A tag and a booklet describing the virtues of the tonic are attached. In the more complicated style (page 135) the bottle is placed in a box, and three pieces of matting are tied around it to create a package of considerable rustic charm.

p. 136 From Ojiya, Niigata Prefecture, comes this package in the shape of an old-style Japanese snowshoe. It is an exact replica and an appropriate symbol, for Niigata is a region of long winters and heavy snows. Made of bamboo, straw rope, and paper dyed in a traditional textile pattern, it contains vegetables pickled in soybean paste.

p. 137, LEFT *Koya-dofu* is one of Japan's traditional preserved foods. To make it, regular tofu (bean curd) is sliced, placed outdoors to freeze in the winter cold, and then dried—a method first used at the famous Buddhist retreat on Mount Koya in Wakayama Prefecture. The package of dried tofu shown here comes from a district in Gumma Prefecture where it is customary to wrap the slices in a creation of rice straw that somewhat resembles a Christmas ornament.

p. 137, RIGHT In the city of Kurume, in northern Kyushu, seasoned barracuda are individually wrapped in pieces of reed matting that resemble the *sudare* (reed blinds) hung in windows and doorways to temper the glare of the summer sun. Traditionally such plants as reed, miscanthus, and wild rice, all of which have long stalks, have been used to make wrapping materials of the kind seen here. The reed-wrapped barracuda is an invention of the sake brewer Kameo Takayama, and the package is indeed an attractive one, particularly since some of the leaves are left attached to the stalks. The boldly printed label enhances the effect.

p. 138, LEFT There is an unmistakable flavor of the farm about this package from Niigata Prefecture. The straw wrapping covers a section of bamboo containing pickled roots of mountain burdock. The handle is formed by cutting the top of the bamboo tube to make two prongs through which holes are bored for the insertion of another piece of bamboo.

p. 138, RIGHT Here a candied papaya from the tropical island of Okinawa is wrapped in a betel-palm leaf to create a simple but strikingly effective package. Like many of the other packages shown in this book, this one has a distinctly regional flavor and, for mainland Japanese, an exotic flavor as well.

p.139, LEFT Plain sheaths of straw like this one from Niigata Prefecture are used to package a number of everyday commodities, including dried fish and preserved vegetables. This is one of the oldest examples of packaging born of rural necessity.

p. 139, RIGHT In the part of Kyushu from which this rustic product comes, it was the custom in olden times to wrap cured wild boar meat in a sheath of straw, wind it in straw rope, and hang it from the ceiling for use as

needed. Here the same kind of wrapping is used as a container for dried persimmons from Nakatsu, a port in Oita Prefecture.

p. 140 *Kanro* is a thick soy sauce, a special product of the city of Yanai, Yamaguchi Prefecture. Here it is packaged in two ways: a bottle wrapped in rice straw and a traditional-style cask for soy sauce or sake wrapped in the same material and tied in a rather dashing style. The labeling is branded on with a hot iron—a technique known since olden times in Japan.

p. 141 Shoyu, or soy sauce, has become a familiar sauce in the West. In former times in Japan it was always sold in kegs like the one shown here, but today, because of the costliness of wood, such traditional containers are used only when shoyu is presented as a gift. There is a feeling of rather heroic muscular force about this robust wooden keg bound with strips of bamboo and sturdily tied with straw rope. The trademark of the producer, which reads "Yamasa," deserves special commendation for its superb design.

p. 142 Appetizers from a food shop in Kyoto come in this elegant lacquered wood box copied from a folding paper lantern. Needless to say, the box is intended for later use, and it is definitely handsome enough to appear on the dinner table.

p. 143 Salted fish entrails are a Japanese delicacy often served with sake. A shop in Okayama City packages this gourmet food in an earthenware container made in the form of a sake bottle and provides it with a sake cup lid. Both the shape and the texture of the bottle make it pleasant to handle, and of course it may be used later to hold sake.

p. 144 Today, when lacquer is often imitated in plastic, especially for packaging, it is refreshing to run across a genuine lacquer container like the one seen here. Designed in an appealing shape, it is used by a Tokyo shop to market tsukudani (food boiled in soy sauce) and of course is meant for later use at home. The unpainted wooden lid, branded with the names of the product and the shop, contrasts nicely with the smooth finish of the lacquer, and the attractively tied twine adds a pleasant homely touch.

p. 145 This comparatively small but sturdily constructed box of paulownia wood contains a paste made of sea urchins: a gourmet food long relished in Japan. The material and style of the box suggest the high quality of the contents, for paulownia is a favorite wood for packaging luxury items, and here it is used with simple but tasteful effect. Seals of dyed paper, imitating squares of woven fabric, add to the feeling of

luxury. The charmingly old-fashioned label reflects the long history of the shop, which was founded in 1804 in Fukui City.

p. 146,
LEFT

Pottery, of course, is one of the mainstays of traditional Japanese packaging, not only because it is attractive in itself but also because a number of commodities cannot be conveniently packaged in any other material. Here the commodity is salted trout entrails from Gifu City, and the container is a simple pot covered with bamboo sheath and tied with paper cord.

p. 146,
RIGHT

The primitive look of this earthenware box is the secret of its charm. It contains spices, and the procession of sixteenth-century Portuguese pictured on its label is a reminder that such spices were among the novelties introduced by these early Western visitors to Japan. The reed cord is in keeping with the spirit of the container. The product comes from Oita City in Kyushu.

p. 147,
TOP

This delectably glazed pot of miso, shaped like a Japanese citron and attractively tied with straw cord, is one of the souvenir gifts sold by the Tokyo restaurant Sasanoyuki, which specializes in tofu dishes. In addition to serving as an example of the sheer tactile pleasure afforded by many Japanese packages, it has a decided flavor of old-time downtown Tokyo.

p. 147,
BOTTOM
LEFT

A Kyoto food shop sells its high-quality pickled vegetables in a miniature teapot of Kiyomizu ware, a well-known type of Kyoto pottery. The handle, like that of most teapots in Japan, is wrapped with a strip of bamboo. The teapot shape is appropriate: such pickles accompany *chazuke* (hot tea poured over rice).

p. 147,
BOTTOM
RIGHT

This ceramic pot from Kyoto contains *natto* (fermented soybeans) intended to be eaten with the mixture of rice and hot tea called chazuke. The folded paper inserted under the twine relates the history of the product. It is tied into a knot in the manner of old-time letters, gifts of money offered at shrines, and the like. There is nothing pretentious about the package, but it still has great appeal.

p. 148,
LEFT

There is a suitably antique look about this bamboo container for powdered tea from Kyoto, for the product is one with a long history, and the beverage made with it has been popular in the teahouses of the Gion geisha district for many years. The label, which goes all the way around the bamboo tube, is of soft old-style paper. In addition to advertising the shop, it describes the virtues of the tea.

p. 148,
MIDDLE

An ordinary section of bamboo, furnished with a bamboo-sheath stopper, serves as a container for powdered leaves of the beefsteak plant,

from which a kind of tea is made. The old-fashioned label, of handmade paper, suggests the venerable history of the product. Here again is an example of the refinement in package design that characterizes the Torindo in Osaka (pages 36, 44, 72, and top right on this page).

p. 148,
TOP RIGHT

Here the well-known Torindo in Osaka displays another container for powdered beefsteak plant leaves: a small ceramic teacup with a bamboo-sheath stopper. The bamboo spoon, of course, is used for scooping out the powdered leaves. The tastefully written label is an effective part of the design.

p. 148,
BOTTOM
RIGHT

The thoughtfulness and care that go into traditional Japanese packaging seem somehow to be epitomized in this small paulownia wood box from a shop in Tokyo. It contains nothing more exalted than toothpicks, but it decidedly makes the point that even this humble commodity deserves an attractive container. Interestingly enough, the box is a copy of those in which *senryo,* the large oblong gold coins of feudal days, were individually placed before being stored together in a large box for safekeeping. The boldly brushed characters for senryo (they are written by hand with black ink, not stamped) are particularly striking, and the faint seal impressions in vermilion ink enhance the charm of the design. Boxes like this come in a variety of sizes. The one seen here has an ordinary lid, but boxes of smaller size have sliding lids sealed with small squares of bright red paper.

p. 149

In the long-ago days when Tokyo was still called Edo, the Yagembori section was the place to buy medicinal herbs. Today a number of the old herb shops survive, but their products are now chiefly spices, and two of the numerous types of containers they use are seen here. The wood-stoppered bamboo tube, more typical as a holder for spices, is equipped with a small wooden plug that is removed for shaking out the contents. The gourd-shaped shaker of polished wood has been skillfully lathed to emphasize the beauty of the grain.

p. 150

The Tokyo restaurant Sasanoyuki has a long history and is famous for its dishes made with tofu. This package, fancifully and rather extravagantly tied with straw rope, contains various specialties of the restaurant and is designed to be used as a gift.

p. 151,
LEFT

Various foods in Japan are preserved by boiling them in soy sauce, and the resulting product is called tsukudani. A Kyoto shop offers its tsukudani in the irresistibly attractive fashion seen here. There is a certain inviting warmth in this combination of pottery and wood, and the knob of twisted vine on the lid is a delightful touch. To Western eyes the purple cord may seem a bit incongruous, but the Japanese have their own ideas

about color harmonies. The bowl, of course, is intended for later use and would be at home in the lovely medley of a Japanese table setting.

p. 151, RIGHT The Terakoya, a restaurant in suburban Tokyo, uses this teacup of Kiyomizu ware from Kyoto as a container for delicacies sold to its customers as souvenir gifts. It comes in a variety of colors and shapes and may be filled with Kizanji miso (soybean paste), *fukujinzuke* (a kind of relish), or *shiokara* (salted fish entrails). A square of printed cloth is tied over the cover with hemp twine.

p. 152 For sheer charm of texture and shape, this sake bottle would be difficult to surpass. Like almost all folk pottery, it is eminently utilitarian, but it has an unmistakable beauty of its own. The bamboo-sheath cover, the rough twine, and the sturdy vine handle all contribute to the primitive effect. The bottle contains sweet sake from Tokyo.

p. 153, LEFT The long-established and well-known Mori shop in Nara, located at the South Main Gate of the Todai-ji temple, uses woodblock-printed paper bags like the one shown here. The design is simplicity itself, but the effect could hardly be more striking. The character in the palm of the hand is the name of the shop, which also sells the product mentioned in the next commentary below.

p. 153, RIGHT The venerable Mori shop in Nara (see preceding commentary) sells the famous local relish called *narazuke* in miniature replicas of old-style water jars. Here once again the delightfully primitive quality of folk pottery is put to good use to make an attractive container. The rope of braided straw makes it possible to convert the jar into a hanging vase after the relish has been used.

pp. 154–155 All the items in this inviting array of packages come from the Shichimiya, a Kyoto spice shop with a history that goes back to feudal days. The ceramic container in the shape of a folding paper lantern (page 154, top) is furnished with a bamboo spoon for dipping out the spice. The four small pots on page 154, bottom, are examples of Kyoto pottery. On page 155, top, the package copies an old-fashioned box used by restaurants for delivering food. Its handle of unfinished wood is a pleasingly rustic accent. The attractively designed pottery containers on page 155, bottom left, (also examples of local ceramic craftsmanship) are meant for later use, and quite obviously they would be hard to throw away. The roof of the bamboo-sheath house on page 155, bottom right, comes off to reveal the small containers of spice inside.

p. 156 Hand-cut sections of cryptomeria wood make a simple but dignified box for dried noodles. The shop in Akita City that sells this product

was founded in 1665. The label, with its numerous seal impressions, has the look of an old-time legal document, and this is fitting, for it is actually the shop's pedigree. It records, among other things, the name of the founder and the fact that the shop, originally located in Inaba, once sold its noodles to the feudal lord of the region by special appointment.

p. 157 Two ways of packaging dry noodles are seen in these products from Sakurai, between Nara and Shimoichi. In the first, on the left, simplicity could hardly be carried further. Sheaves of soba (buckwheat noodles) are tied at each end with bands of thin rice paper and bound at the center with a label written in admirable calligraphy to suggest the high quality of the product. On the right, similar sheaves of the very thin noodles called *somen* are wrapped in single sheets of tastefully dyed paper.

p. 158 Packaged lunches are common fare in Japan, especially among travelers, and they appear in a great variety of containers. There is an ironic and yet somehow appropriately "Zen" humor in the fact that Bodhidharma (Daruma in Japanese), the legendary founder of Zen, should appear on the cover of a lunchbox, but of course the ceramic box seen here copies the famous Daruma doll, a good luck symbol in Japan. This whimsical package is sold at the railroad station in Takasaki, Gumma Prefecture—a station, incidentally, that is noted for the large assortment of lunchbox meals that it provides.

p. 159,
TOP LEFT Northern Japan is well known for its production of the traditional stylized wooden dolls known as *kokeshi*. This charmingly designed ceramic lunchbox, sold at railroad stations in Yamagata Prefecture, copies the head of a kokeshi.

p. 159,
TOP RIGHT This small earthenware teapot is a familiar sight in railroad stations throughout Japan. It holds the hot tea sold to travelers to accompany their lunchbox meals. Cheaply made and quite unpretentious, it is nevertheless engaging in design and altogether pleasant to handle. The cover, of course, serves as a cup, and the handle is a simple strand of wire. Regrettably, this humble container seems doomed to disappear from the scene, for it is now frequently replaced with plastic imitations, uninviting though the idea of drinking tea from plastic may be.

p. 159,
MIDDLE
LEFT Among the packaged lunches offered for sale at the railroad station in Fukuyama, Hiroshima Prefecture, is this appealing ceramic container of Inland Sea tai (sea bream) mixed with boiled rice. The lid, of course, represents a tai.

p. 159,
MIDDLE
RIGHT

At the railroad station in Chiba City, vendors offer a lunch of grilled clams, rice, bamboo shoots, and other kinds of food, all temptingly packaged in a net-wrapped container that simulates a clamshell. The net copies those used by shellfish gatherers on the beaches of the Chiba district.

p. 159,
BOTTOM
LEFT

There is an endless variety of packaged lunches in Japan, but this product from Nagano City is quite unusual among railroad-station meals. The pottery bowl, which contains a fairly standard stew with noodles, is distinguished by especially attractive lines, and the arrangement of the characters on the pressed-paper cover is most artistic.

p. 159,
BOTTOM
RIGHT

A ceramic copy of an old-fashioned rice steamer is used throughout Japan to market a railroad-station lunch of rice, meat, and vegetables. It would be hard to think of a more appropriate container, and its homely look seems to enhance the appeal of the food inside. Travelers who buy this packaged lunch often take the container home with them for later use, but younger Japanese sometimes do not know what it represents, for the electric rice steamer has taken over almost completely in recent years.

pp. 160–161

The peculiar attractiveness of the commonplace could hardly be better expressed than here. Once again, this is packaging (if one can really call it that) born of rural necessity—in this case a product of the northern prefectures of Nagano and Miyagi. Thin cakes of tofu, first frozen and then dried, are strung together with straw so that they can be hung from the ceiling and used as needed, since they can be preserved for a long time. There is nothing out of the ordinary about tofu, long a Japanese staple, but here it is given a truly enticing look.

p. 161,
RIGHT

To make mochi, steamed rice is pounded to the consistency of a thick paste and then shaped into cakes. The Kaga mochi seen here, variously flavored with ingredients like soybeans and seaweed, are dried mochi from Komatsu in Ishikawa Prefecture (the Kaga Province of feudal times). Drying is a common method of preserving giant white radishes, tofu, fish, and other foods. The rice stems used to tie the Kaga mochi together retain their heads of grain as a symbol of festive occasions. Since both the mochi and the stems represent the same plant, the combination is indeed a congenial one.

pp. 162–163

Like the tofu on pages 160–161, shrimp and fish are often preserved by drying them and stringing them together with straw. This age-old technique is also used for other foods, including the giant white radishes called daikon. The purely primitive look of these "packages" is their outstanding attraction, but there is also an appeal to the appetite.

The dried shrimp seen here are from Kagoshima, the southernmost prefecture of Kyushu; the dried flying fish are a delicacy from Miyagi Prefecture in northern Honshu.

p. 164 Since ancient times the Japanese have savored dried persimmons as "natural sweets." In Fukushima Prefecture it is traditional to tie the persimmons on lengths of rice-straw cord and then bind the ends of the cords together in a graceful arrangement that suggests a spray of flowers.

p. 165 Rice straw is both a cheap and an abundant material, and its uses are legion. Here, in an example from the Kanto region (the eastern part of Japan, centering in Tokyo), it serves for stringing red peppers together before they are hung from the eaves of a farmhouse to dry.

p. 166, This whimsical bottle of Bizen ware goes by the name of *tanuki tokkuri,*
TOP LEFT or badger sake bottle. Like the packages seen on pages 134–135, it contains the famous medicinal liqueur homeishu from the city of Fukuyama in Hiroshima Prefecture. To pour out the liqueur, one unties the cords and removes the hat-shaped stopper. After the bottle has been emptied, it can be used as a flower vase or simply as an ornament.

p. 166, *Shochu* is a rustic liquor distilled from one of a number of grains and
TOP RIGHT vegetables, including rice, wheat, and sweet potatoes. The ceramic container shown here is used for a brand of shochu from Fukuoka Prefecture called Hakata Kojoro and nicknamed *kappo-zake* because of the lip (*kappo*) with which its bamboo stopper is furnished to facilitate pouring.

p. 166, This sake bottle of white porcelain from Yoshizaki, Fukui Prefecture,
BOTTOM is made in the shape of a gourd, since gourds were often used in old
LEFT Japan as containers for sake. The silk cord copies the ones that were used for carrying the gourds. The gold paper sealed over the stopper completes the effect of deluxe quality.

p. 166, The brand name of the sake in this ceramic bottle from Takayama, Gifu
BOTTOM Prefecture, is Dashi, or Festival Car. It is a most appropriate name, for
RIGHT Takayama is the scene of an annual festival noted for its procession of beautifully decorated floats. The bottle itself is of the same honest and unpretentious style that characterizes Takayama and its inhabitants.

p. 167, Although this earthenware bottle is of a fairly ordinary type, it is
TOP LEFT dramatized, so to speak, by the charmingly designed label and the reed cap tied with hemp twine. It contains *yakuzake,* a liqueur said to promote good health, and it is sold by a shop in Takamatsu in Shikoku.

p. 167,
TOP
RIGHT
This ceramic bottle with a design of peonies contains high-grade sake from Toyama Prefecture. Although it is a modern product, it represents centuries of tradition, and it carries something of the flavor of the locale. The peony symbolizes opulence, and indeed the design matches the rather opulent shape of the bottle. The paper cover and the silk cord add to the richness of the effect.

p. 167,
BOTTOM
LEFT
In spite of its heavy and attractively sturdy look, this is quite a small bottle, for it contains less than half a pint of sake. Of ordinary folk pottery, it makes no effort to be artistic, but it is evident that much thought has gone into the design. This friendly product comes from the city of Shirakawa in Fukushima Prefecture north of Kasama, where it is sold in the railroad station for the convenience of travelers. Agreeably enough, it is accompanied by a small sake cup. The bold calligraphy is brushed on each bottle by hand before it is fired.

p. 167,
BOTTOM
RIGHT
A *tokkuri* is a sake bottle, and the *kokeshi tokkuri* of Miyagi and Yamagata are sake bottles that copy the shape and style of the traditional kokeshi dolls for which these two prefectures are famous. Regrettably, these ceramic bottles are now no longer made, but the manufacture of kokeshi dolls still flourishes. It is interesting to note that the top of the bottle is a cup for drinking the contents.

p. 168
Awamori is a kind of millet brandy originally produced in the Ryukyu Islands. In Kagoshima City, at the southern end of Kyushu, it is sold in stout earthenware bottles like this one: a very suitable container for an inexpensive but potent liquor. The reed cap contrasts pleasingly with the rather somber tone of the pottery. A length of hemp twine secures the cap and forms a loop for carrying the bottle.

p. 169
Awamori (see commentary for page 168), a traditional liquor of Okinawa, is also known as Ryukyu awamori after the name of the island chain to which Okinawa belongs. In its native locale it is sold in ceramic jars of the type seen here. Such jars are wrapped in hemp-palm rope to protect them from breakage and make them more readily portable. This one has a capacity of two quarts, but some are large enough to hold five gallons.

p. 170
This robust and delightfully earthy jug is a fitting container for the health-giving liqueur called yakuzake, in this case a product of the town of Fukuyama, Hiroshima Prefecture. The jug itself is an example of the famous Bizen ware of neighboring Okayama Prefecture: a folk product long admired for its subdued beauty of color and texture. The bamboo-sheath cap imitates an old-time warrior's helmet with decorations in the form of antlers, and the handle, which adds to the

impression of earthiness and vigor, is made from pliant boughs of *katsura,* the Japanese Judas tree.

p. 171 Yakuzake (medicinal sake) from Yamagata City is sold in squat earthenware containers like this one. The soft texture of the square of red cloth tied over the top contrasts most effectively with the rough texture of the pottery, and the straw rope, attractively tied to form a handle, is an excellent finishing touch.

p. 172 Sake in bulk form is traditionally sold in wooden casks wrapped in reed matting and sturdily bound with reed or straw rope. The standard cask contains slightly more than 19 gallons, but the one used here is a smaller version designed to serve as a gift. It comes from Nada, a part of Kobe and a brewing center long famous for the quality of its product. The large symbol is a stylized form of the character for "rice," and rice, of course, is the grain from which sake is made.

p. 173, The Japanese name for this small but handsome sake container of wood
LEFT bound with split bamboo is *tsunodaru:* "barrel with horns." It comes from Shimane Prefecture and is intended for sake offered as a gift on felicitous occasions. The lid is not seen here, but the long wooden peg is the bung, and the transverse piece behind it, although mainly decorative, may be used as a handle for carrying the container or pouring the sake.

p. 173, Wooden casks bound with split bamboo have been used in Japan
RIGHT since early times for marketing sake, soy sauce, and other liquids in bulk. Here a neatly made miniature version of the traditional cask is used for sake from Shimane Prefecture. The spout is a small bamboo tube. Since the cask is designed for table use, it may serve later as a container for soy sauce or other condiments.

p. 174 This stunningly wrapped package contains a well-known product of Nara: the relish called narazuke, which has been made there since olden times. The thick old-style paper, decorated with calligraphy in a masterly hand, is reminiscent of the square of silk crepe used as an accessory in the tea ceremony. Everything about the package suggests the choice quality of the contents.

p. 175 The furoshiki, the ubiquitous square of cloth that is used in Japan to wrap practically anything and everything to make it portable, appears here as the wrapper for boxes of dried bonito from a shop in Tokyo. There is, of course, no limit to design and color among furoshiki, and they also vary in size, although the ones most commonly used are about three feet square. The furoshiki seen here are emblazoned with a character that has the doubly felicitous meaning of "congratulations" and "long life."

p. 176 Mochi (cakes of steamed and pounded rice) can be dried and pre-
 served for a considerable time. When they are wrapped in straw, they
 have sufficient ventilation to keep them from spoiling or losing their
 flavor. This manner of preserving mochi is peculiar to such northern
 areas as the prefectures of Akita and Iwate, where packages of mochi
 like the ones shown here are often hung from the eaves of houses
 during the severely cold winter. This graceful arrangement of rice straw
 also serves as a *tsuto* (see commentary for page 177).

p. 177 This type of straw package, known as a tsuto, comes from a farm
 in Kyoto Prefecture. It is a replica of the packages in which tenant
 farmers once delivered freshly harvested agricultural products to their
 landlords. The tsuto is one of the most elaborate of straw packages,
 and it illustrates the rural style of wrapping gifts offered to superiors.

pp. 178–179 Like the wrapper for eggs on page 26, the straw rice bag, now rarely
 used, was an invention born of necessity. Here an agricultural byprod-
 uct that might otherwise have been discarded was put to good use,
 and nothing from the rice harvest was wasted. Bags of the type shown
 here usually measured some two feet or more in diameter and slightly
 under five feet in length and held roughly 130 pounds of rice.

p. 180 Surprisingly enough, this festive-looking bag of bark-flecked rice paper
 is not for candy but for dry glue. It comes from a shop in Tokyo, one
 of the few that still sell this old-time natural product in a day when
 chemical glue has almost completely taken over. Several sizes of
 packages are sold, including small envelope-shaped ones of the same
 handmade paper. Each is stamped with the name of the product and
 various seals suggesting its long history.

p. 181 Incense in Japan is used mainly for religious purposes: in Buddhist
 temples and at funerals or memorial services for the dead. The attrac-
 tive ceramic container seen here is used by a Tokyo shop to package
 incense in powdered form. Its tasteful design is in keeping with the
 traditional idea that ceremonial incense should be rather simply but
 elegantly packaged. To break the seal, one pulls the cord over which it
 has been pasted.

p. 182 Ceremonial incense in stick form is packaged here in a beautifully
 crafted box of paulownia wood. The inner wrapping of handmade
 paper is hardly less than sumptuous, but it is appropriately restrained
 in color and design, since boxes of incense like this one are favored as
 condolence gifts for bereaved families. The package comes from the
 Kyukyodo, a Tokyo shop famous for its stationery and folding fans as
 well as for its incense.

p. 183 Exquisite incense in an exquisite package comes from the Kyukyodo in Tokyo. The incense itself has been a treasured product since the Heian period of more than eight centuries ago. The flat ceramic container (bottom) is first wrapped in a sheet of delicate handmade paper and then enfolded in five more sheets of handmade paper in graduated sizes and varying colors. This outer wrapper (top) suggests the costume of an aristocratic Heian lady: a number of flowing robes of graduated size worn one over another to create a rainbow effect.

p. 184 Books have always been treated with respect in Japan, and particularly valuable ones are provided with boxes or cases like this one from Tokyo. Here the design is modern, but the idea is traditional. The material is paper, and the fastener consists of a peg of bone slipped through a loop of silk cord. The book itself deals with the famous wooden dolls called kokeshi, which have been popular since long ago, and its cover is appropriately decorated with a small kokeshi in the style of a relief.

p. 185 These small and skillfully crafted boxes of paulownia wood contain miniature woodcarvings of the twelve animals of the Chinese zodiac. Both the boxes and their contents are the work of one man, Koji Ogura, who makes them in the town of Iwai, Tottori Prefecture. Such carvings are sold as amulets or charms, and one chooses the animal for the year of one's birth (the cycle goes by years rather than by divisions of a single year as in the Occidental zodiac). Of special interest here is the bold and beautiful style in which the craftsman writes the characters for the zodiacal animals with brush and ink.

p. 186 Like the tops on the following page, this is a toy—a product of Tottori City—and its only connection with traditional packaging is that it copies the mats used to close the straw bales in which rice is packed for the market. It is interesting, nevertheless, for its clever use of such a cheap and common material as straw, and there is no denying its charm. The two dolls, made of paper and wood, represent the emperor and empress who occupy the chief places in the traditional Doll Festival display on March 3.

p. 187 The town of Naruko, Miyagi Prefecture, is noted for its lathework and has long been known as the home of the kokeshi doll, a lathe-turned product found throughout the length and breadth of Japan. Here the talents of the Naruko craftsmen are charmingly displayed in an assortment of wooden tops and their brightly decorated container. The tops delightfully represent, in clockwise order from the bottom, a chestnut, an eggplant, a mandarin orange, an apple, and a persimmon.

p. 188 These festive paper packages are examples of those that accompany the ceremonial gifts exchanged between the families of engaged

couples. In keeping with a time-honored tradition, they are designed to contain lists of the gifts presented, and their decorations, as well as their shapes, are symbolic of the auspicious occasions on which they are used.

p. 189 This strikingly designed envelope, with white characters on a vivid red ground, is designed for congratulatory gifts of money—for example, by companies to employees when profits have been unusually good. The characters read *o-iri,* an expression originally used in theaters and meaning "full house." The festive color scheme and the boldness of the design strike a refreshing note in the hectic business world of today.

p. 190 Japanese etiquette frowns on offering a gift of money without first wrapping it in one way or another. Even if it is only a matter of a tip at a traditional-style inn, and sometimes even at a Western-style hotel, the money is first wrapped in a piece of paper. In the example shown here the coins are placed in the center of a square of plain white paper that is then folded upward to resemble a flower. It is a most primitive form of wrapping, retaining traces of the purification ritual, but it serves the purpose quite well. One can also buy small decorated envelopes for use on such occasions.

—*Translated from the Japanese and adapted for Western readers by R.F.*

Bibliographical Note: Hideyuki Oka's first book on traditional Japanese packaging was *Nihon no Dento Pakkeji* (*Japan's Traditional Packages;* published by Bijutsu Shuppan-sha, Tokyo, 1965) or, in its English version, *How to Wrap Five Eggs* (Weatherhill, Tokyo, and Harper and Rowe, New York, 1967). His second book was *Tsutsumu* (*Wrapping;* Mainichi Shimbun, Tokyo, 1972). This book, based in part upon the two earlier books and also containing new material, was originally published as *How to Wrap Five More Eggs* (Weatherhill, New York and Tokyo, 1975). It was published to coincide with an exhibit organized by the author under the sponsorship of the Japan Society of New York and The American Federation of Arts, to tour the United States during 1975–1976, opening at the Japan House Gallery, New York. (A paperback edition of this book was published simultaneously under the title *Tsutsumu: An Introduction to an Exhibition of the Art of the Japanese Package,* published by the sponsors of the exhibit.) This edition of *How to Wrap Five More Eggs* has been retitled *How to Wrap Five Eggs.*

WEATHERHILL

AN IMPRINT OF SHAMBHALA PUBLICATIONS, INC.

Horticultural Hall

300 Massachusetts Avenue

Boston, Massachusetts 02115

www.shambhala.com

9 8 7 6 5 4 3 2 1

Printed in China

⊗This edition is printed on acid-free paper that meets the American National Standards Institute z39.48 Standard.

Distributed in the United States by Random House, Inc.,

and in Canada by Random House of Canada Ltd

Library of Congress Cataloging-in-Publication Data

Oka, Hideyuki, 1905–1995.

[Kokoro no zokei. English]

How to wrap five eggs: traditional Japanese packaging / by Hideyuki Oka; with photographs by Michikazu Sakai.

p. cm.

Previously published under title: How to wrap five more eggs.

ISBN 978-1-59030-619-2 (pbk.: alk. paper)

1. Gift wrapping. 2. Packaging. 3. Decoration and ornament—Japan. I.

Oka, Hideyuki, 1905–1995. How to wrap five more eggs. II. Title. III. Title:

How to wrap 5 eggs.

TT870.O3913 2008

745.54—dc22

2008018982